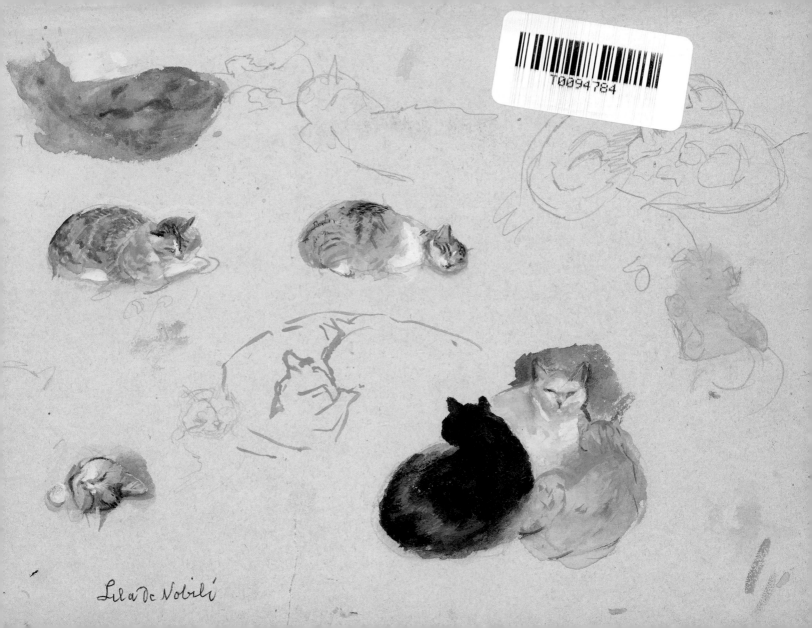

Lila de Nobili

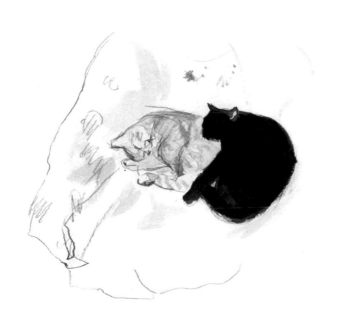

Published by Officina Libraria, Milan
Publisher and Editor in Chief
Marco Jellinek
Publisher and Art Director
Paola Gallerani
Managing Editor
Serena Solla

Translation
NTL, Florence
Editing
Collettivo Libraria *with* Nicolò Rossi
Design by
Paola Gallerani

Color separation
Giorgio Canesin, Cernusco sul Naviglio (Milan)
Printed by
Grafiche Tintoretto, Villorba (TV)

isbn: 978-88-99765-94-1
© Officina Libraria, Milan, 2018
www.officinalibraria.net

Printed in Italy

Special thanks to Monique Dreyfus who has given access to the majority of the works published in this book, and to Gianni De Nobili who found the short story published at the end of the book amongs Lila's papers.
We also wish to thank Filippo Crivelli, Christine Edzard, Olimpia Hruska, Claudine Lachaud, Anna Malatesta, François Paillocher, Jacqueline Pecker, Coralie Sanvoisin, Dino Trappetti, who have given permission to reproduce the works of art in their possession and, for various reasons, Adriano Bon, Raphaël Chipault, André Collin, Coralie Cousin, Vittoria Crespi Morbio, Paola Gallerani with Leo and Teo, Fabrizio Garzi Malusardi, Marco Jellinek, Fiorella Mariani, Chloe Obolensky, Gami and Jessica Postigo, Nicolò Rossi, Raimondo Santucci, Michel Sanvoisin, Serena Solla, Eugenio Toso.

Photo Credits
Raphaël Chipault (endpapers, pp. 1, 4-6, 14, 19, 20-30, 32-38, 43-49, 51, 52, 54-59, 61-70, 79 [l], 80 [r], 81-85, 88, 89, 91, 92, 95, 96, 98-103, 110, 111, 117, 122, 130); Coralie Cousin (pp. 40, 72); Claudie Gastine (p. 106); Raimondo Santucci (pp. 9, 31, 50, 60, 75-78, 79 [r], 80 [l], 86, 87, 90, 93, 94, 97, 104, 109, 115, 118-121, 126-129, 131); Giorgos Tourkovassilis (p. 138).
Please contact the publisher if you are a copyright holder who has not been identified correctly.

Lila De Nobili

Cats
of Paris
and Elsewhere

edited by
Claudie Gastine and Francesca Simone

OFFICINA
LIBRARIA

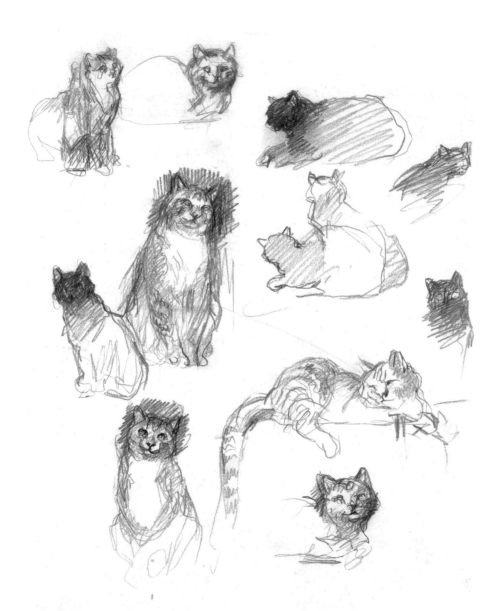

How to use the Croque-Grisette device (patented): hold the eyepiece perpendicular to your line of sight, parallel to your face, Tilted upwards, downwards or straight. Croque-Grisette, patented model, rue du Foin.

Table of contents

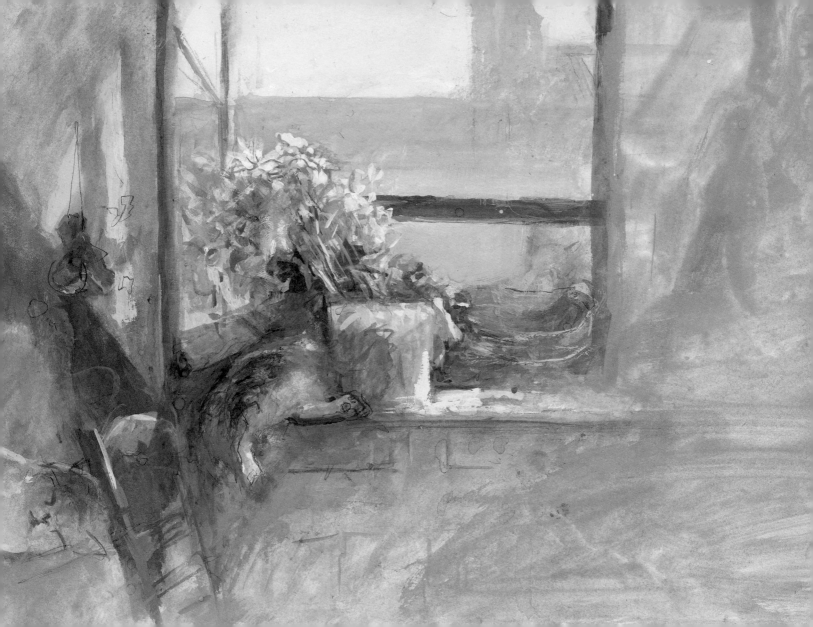

Introduction

*T*he air of freedom that wafts through Paris has always drawn artists to the city from all over France, Europe and indeed the world. One of them was Théophile Alexandre Steinlen, an anarchic Swiss painter and engraver who, at the end of the nineteenth century, created the well-known poster for the Montmartre cabaret 'Le Chat noir' featuring an indomitable, dishevelled cat, already made famous by the song by Aristide Bruant and then a symbol of nonconformism among Bohemian artists. The cat had already been celebrated since the middle of the century as an emblem of freedom among writers and artists both Parisian by birth, such as Baudelaire and Manet, and by adoption, such as Colette and Foujita.

And so it was for the Italo-Hungarian painter Lila De Nobili (1916–2002), who moved to Paris at the end of the war in 1945, settling in the quarter of Faubourg St Germain—where she remained for the rest of her life—starting out in an apartment in rue de Lille and then moving in 1961 to one in rue de Verneuil with three mansarded rooms overlooking a courtyard.

This was the district of Saint-Germain-des-Prés, the beating heart of Paris, which drew intellectuals from all over the world and where Lila lived just a short walk from all she loved: the atelier of Delacroix, the École des Beaux-Arts on the Quai Malaquais and the Louvre on the other side of the Seine, crossing over the Pont des Arts.

Lila worked as a set and costume designer for around twenty years, and her creations for La Scala in Milan, the Paris Opera, Covent Garden in London and countless other theatres enchanted the whole world.

Sought after by the most celebrated European directors, she designed costumes for many of the best-known singers and actresses of the time, including Maria Callas, Édith Piaf, Audrey Hepburn and Ingrid Bergman.

Shortly after the events of May 1968—which she participated in passionately, sketching everywhere, including the Sorbonne and other occupied locations—Lila decided to stop working for the theatre. She did, however, continue to host and help the young decorators that she had worked with in the previous years. Gradually, these were joined by a new generation marked by the hippie movement, young men and women with long hair who lived in a small room looking onto the same landing as Lila. Her door was always open and she welcomed them with a kind heart, listening to them and creating their portraits.

One day, a young man arrived with a Siamese cat named Ulysses on his shoulder and a guitar under his arm. Ulysses often travelled with his owner, but sometimes he stayed in rue de Verneuil and Lila took care of him, in the end adopting him.

More cats of every hue and origin followed, and Lila, who described the world with her pencils and brushes, soon had a large feline community to care for and paint whenever she liked.

Her cat portraits, drawings and sketches grew in number and were often given as gifts to members of the circle of friends that Lila had gathered around herself, people of every age and nationality, the sole common denominator among whom was art, in particular painting, in all of its forms and applications.

One of her closest friends was Monique D., who she met in the 1980s at the École des Beaux-Arts, where she was an occasional model. They had much in common and their bond was strengthened when Lila invited her to come draw in her studio. Both vegetarian, Lila and Monique shared the belief that every living creature, human or animal, needed to be respected and protected, to the point that Monique even took in abandoned cats and dogs. They were such great friends that Lila entrusted Monique with her last cat, Mitzi, when she was no longer able to care for her.

At the end of her life, Lila carefully organised all of the drawings that had accumulated in her portfolios over the years and gave Monique most of the ones with cat subjects.

It is our desire to share these works—most of which are from Monique's collection—with the public that has led us to publish this volume, intimate testimony to the poetic universe of Lila De Nobili.

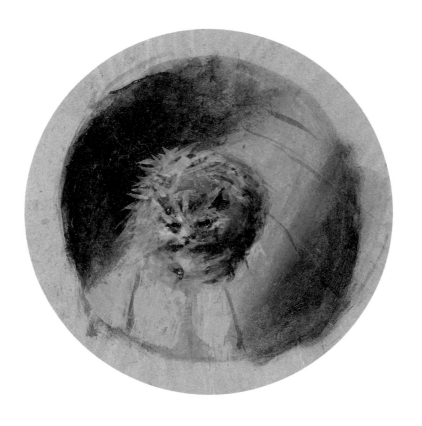

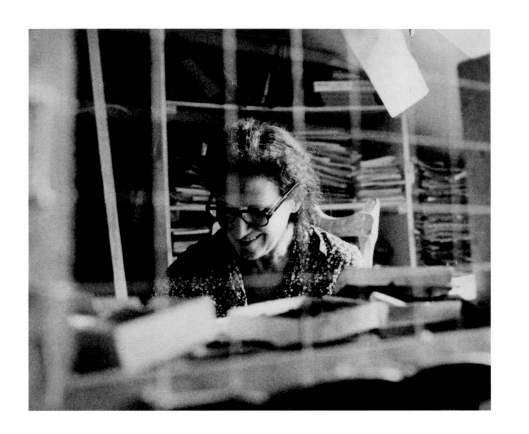

Biography

Lila De Nobili was born in 1916 in Castagnola (Lugano, Switzerland), at the crossroads of two worlds: that of her father, Prospero, the descendent of an old noble family from La Spezia, and that of her mother, Dola, a Jew from Hungary and sister of the artist Marcel Vertès.[1]

As a child, Lila travelled constantly with her parents, moving between La Spezia and Rome, Paris and Budapest, Genoa and Venice, Nice and Lugano. She also journeyed with them across the Atlantic, to New York, where her father, having retired from political life in Italy, where he was a member of Parliament and under-secretary of the Treasury, opened a cigar factory. During these frequent moves, the family stayed in luxury hotels and associated with artists and intellectuals from all over Europe, but what might appear to have been a life of privilege failed to satisfy the young Lila, who dreamt instead of discipline, school and clearly defined roots. Her only chance to enjoy a normal school year was between 1929 and 1930, when she attended a local school in Nice, where her father owned a villa. This was a happy time uninterrupted by travel: 'for me, school, which I got in dribs and drabs, was sheer joy.'[2] When she was eleven, she received her first box of oil paints and began to 'draw everywhere, it didn't matter where, it didn't matter when.'[3] She studied off and on at the Académie Julian and the Académie Ranson in Paris and then, later, in Rome, she took a decoration course taught by Ferruccio Ferrazzi at the Accademia di Belle Arti, where she earned her diploma in 1939.

For Lila, the lack of opportunity to devote herself to the constant study of drawing and painting was distressing, a gap that she would feel her entire life. At the academy in Rome, she met Virginia Bizzozero, and the two became close friends, united by a shared rational approach to colour. Lila wrote: 'She was the first person I met that knew how to look the way a musician listens.'[4]

She also reconnected with her childhood friend Renzo Mongiardino,[5] and together they shared ideas about literature, cinema, painting and architecture. Right from the beginning, she had a very close work relationship with Renzo, and indeed she was the first painter/decorator to collaborate with the young architect.

Many years later, she wrote: 'With Renzo and Virginia, Rome became a fascinating place through Borromini and Bernini,'[6] two fundamental ties that remained strong until the end of her life.

It is probably in this period that Prospero, a staunch opponent of fascism, renounced his Italian citizenship to adopt that of his Hungarian wife.

When the war broke out in 1939 all relations with Paris were cut and the De Nobilis moved to the Grand Hôtel in Rome. In 1942 the villa in Nice, the family's only real residence, was requisitioned.[7] In the same year Lila began working as a fashion illustrator for the women's magazine *Bellezza*.

In 1943 Allied bombing of the city and increasing racial persecution drove the family to leave the country. The De Nobilis took refuge in Lausanne, and it was during this period of exile that Lila made her first pastel and oil portraits. She had a special empathy with her sitters, veiled with a touch of irony that she inherited from her uncle Vertès, who she admired and was an important source of support. She wrote: 'Vertès talks about fashion as if it were satire, while preserving its grace.'[8] She continued to work as a fashion illustrator, taking inspiration from a few issues of *Vogue*, to which Vertès was a regular contributor and made it as far as Lausanne.

At the end of the war, she moved to Paris, where she was soon joined by Dola, following Prospero's death, that took place in December 1945.

During the period immediately after the war, a time of great ferment, when Lila was living in rue de Lille with her mother, her street was a stage for the entire Parisian art world, theatre people, artists, writers and great couturiers. It was a time that seemed straight out of a film by Marcel Carné or Jean Renoir, with a uniquely French naturalistic vision. It was the time of Dior's *New Look* and Cocteau's film *La Belle et la Bête*, with sets by Bérard, which were to have as much influence on Lila's first set designs as the more naturalistic tradition of Italian Neorealism.

In the meantime, Vertès put Lila into contact with *Vogue*, with which she began a regular collaboration, drawing the models of the collections of Christian Dior, Elsa Schiaparelli and Lucien Lelong, while also designing windows for Hermès.

In 1947, her life and work changed direction: Françoise Lugagne, who knew Lila during her childhood in Nice, introduced her to her husband, the director Raymond Rouleau. It was with Rouleau that Lila created her first stage sets, for Patrick Hamilton's *Rue des anges*.[9] Even without special training in the field, Lila threw herself passionately into the theatre world: her sets and costume designs charmed audiences and she worked with great directors, including Luchino Visconti, Gian Carlo Menotti, Franco Zeffirelli and Peter Hall, working on no fewer than fifty productions (plays, opera, dance)—more than twenty of which with Rouleau, with whom she was especially close—over a career lasting about twenty years.

In the mid-1950s, she met the costume designer Piero Tosi[10] through Visconti, and it was with him that she developed her philological knowledge of costume. In Paris, she became close to Lydia and Rostislav Doboujinsky, Russian decorators from St Petersburg steeped in the tradition of the *Ballets Russes* and the culture of *Mir Iskusstva* (World of Art). In a continuous exchange between France, Italy and England, a group of young costume designers, set designers and decorators formed around the Doboujinskys, Lila and Renzo Mongiardino.

In the 1960s, Lila moved on her own to the three *chambres de bonne* in rue de Verneuil, which were close to everything that she loved: the Louvre, the Bibliothèque des Arts Décoratifs and the Hôtel du quai Voltaire, where her mother Dola had decided to retire.

In the 1970s, Lila stopped her work for the theatre world, which frequently required travel outside Paris, in order to stay near her mother. She wanted to leave the grand productions on which she had left her singular mark, freeing herself to return to the study that she felt was lacking in her youth. Her relationship with the theatre world always remained alive, however, and Lila guided the young people that she had helped train towards the directors she had worked with.

An intense relationship of reciprocal exchange on art and painting was formed with the Greek painter Yannis Tsarouchis,[11] who arrived in Paris in 1967 and who she had already met when working at La Scala. During Yannis' Paris years the two artists worked together and they organised a short-lived art school, which they called the *Accademia*, where the young people gathered around them could draw from life. This was the period during which the apartment in rue de Verneuil was frequented by people involved in the 1968 events, who often stayed for some time with Lila, such as Marc-Michel, who came with his cat Ulysses, marking the beginning of 'Lila's big cat family.'

Finally master of her own time, Lila can devote herself to the study of art and painting techniques.

In Paris she starts painting on porcelain and she attends a course for painting icons with a Russian teacher; in 1979, after the death of her mother, she attends a study session at the Institut supérieur de peinture decorative Van Der Kelen in Brussels.

From Nicholas Wacker, who Lila had met in her youth at the Académie Ranson and now teacher at the École des Beaux-Arts in Paris, she learns and then passes on a technique close to that of the Van Eycks.

In London with Christine Edzard[12] she works on chromolitographs studying the technique of the Pointilliste movement and of early color photography.

Lila travels frequently to Italy: in Vezzano, where her De Nobili cousins live, she restores the chapel of the old family home; in Milan, she creates copies of old paintings or she paints portraits for a select group of art lovers.

She loves to spend time and paint in Aubagne, Provence, where friends host her in two independent rooms. Here she makes a series of copies from Giovanni Boldini, in collaboration with Emilio Carcano.

In 1995 in Spoleto, with the assistance of Fiorella Mariani, she curates an exhibitions dedicated to her uncle Marcel Vertès and she writes the catalogue.

As old age advances she must renounce to the travels that had brought her all over Europe and, becoming progressively deaf, she must abandon the use of the telephone; but she keeps her network of contacts writing and receiving letters form every corner of the world.

During the last years of her life, surrounded by a close group of friends, she communicates with them and with the many visitors through notebooks. She still paints a few portraits and she sorts her correspondence and drawings.

She died in Paris in 2002.

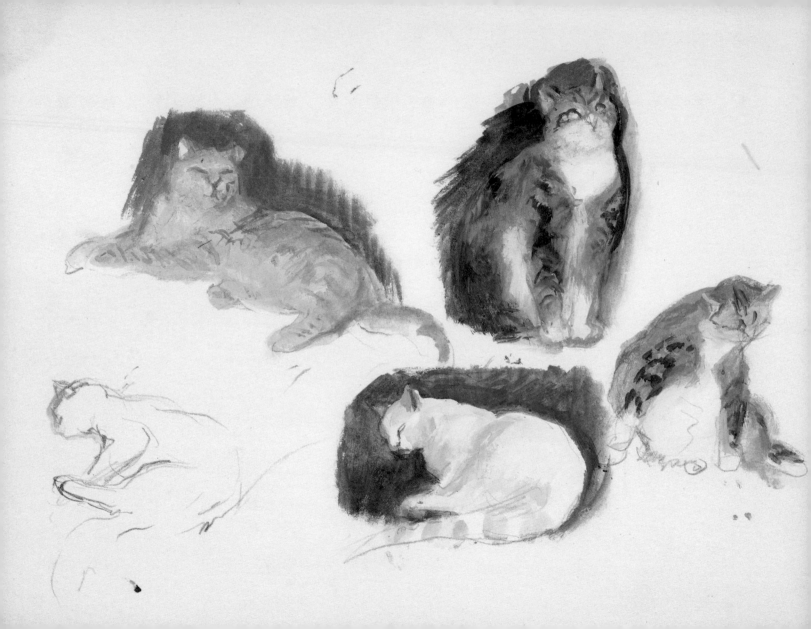

rue de Verneuil

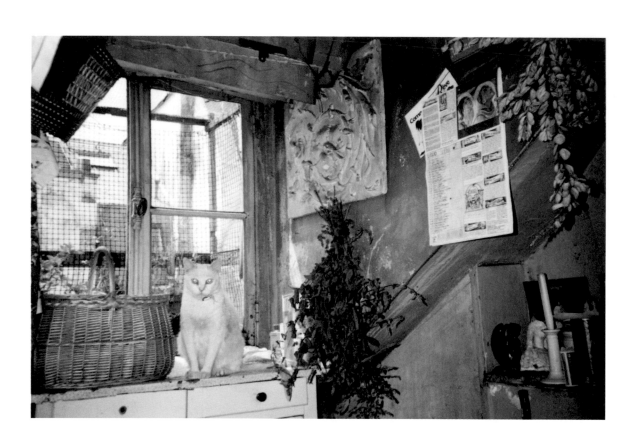

When the war ended in 1945, Lila moved to Paris. At first she lived in two rooms in the hotel at 20, avenue Victor Hugo, where she had stayed as a child with her family. Her accommodation was temporary and makeshift, the unheated rooms furnished with just a few pieces brought from the villa in Nice, but Lila was happy in her new city[1] and glad to finally have a place of her own.

At the end of December that same year, her father Prospero died in Montecarlo, and her mother Dola came to stay with her at the hotel in Victor Hugo. In October 1946, they moved together to an apartment at rue de Lille 9,[2] between the Quai Voltaire and the Boulevard Saint-Germain, in the quarter that became her permanent home.

It was only at the beginning of 1961, after living in Paris for more than fifteen years, the Lila moved into the three mansarded rooms in rue de Verneuil that were to be her home and studio for the next forty years. To get there, you needed to climb a narrow staircase and, after having gone through a long corridor, guided by the odour of milk with coffee and cats, up four more floors of steep stairs.

Then, walking through a glass door that closed the landing of the last floor, you entered the central room of her apartment, the kitchen, which was the only one of the three open to all, whether visiting friends or resident cats. Her little stove was always ready to heat up water for tea or prepare coffee in her beloved Neapolitan coffee pot. This was the room where her cats prowled around and slept: Ulysses, Rodecka, Rouki, Mitzi, Bianco (the White Cat), Dominique and Grisou il Ragioniere (the Accountant). There were books and photocopies of books everywhere, on the shelves, on the chairs, on the floor, calling to mind Apollinaire's dream of having 'a cat who walks among the books.'[3]

When not occupied by a ball of embracing cats, the sole armchair, often draped with a sheet, was reserved for visitors. The ocher walls were covered with casts, photos, chromolithographs, drawings and paintings of friends, unframed and hung with small nails.

At the back of the room, there was a garret window that, facing south, bathed humans, cats and objects alike in a singular clear light that transformed the corner of the mansard into a small stage. The cats' favourite observatory was in the alcove below this window: a white cupboard decorated with a few plants and, often, a large bunch of garden flowers brought by a friend.

The door to the studio opened on the left. In this space, reserved for work, one found a glass cabinet with doors filled with jars of

pigment, brushes and products for preparing supports. There were also two tables covered with tubes of tempera and oil paint, palettes and, on the walls, studies, colour samples, and casts. Portfolios of every shape and size rested on the floor against the wall shared with the kitchen. That is where Lila worked, along with those she occasionally invited to share the space.

The room was theoretically off-limits for the cats, as she wrote in a letter:[4] 'Here, all is calm, except at home, where the struggle between cats and objects is creating a civilization of dams, much like the Dutch built: a kind of interior design.' But, in spite of her attempts to create barriers, the cats often managed to slip through them, taking advantage of a moment of distraction and then, to express their resentment at having been kept out, knocking over the cans of pigment and walking over her paper and drawings with freshly stained paws. In the early 1980s, Lila wrote:[5] 'My Siamese kitten is now pink because [the cats] knocked over the madder.' Once again we are reminded of a poet's cat, Snow, who Mallarmé benevolently wrote 'erases my poetry with her tail, walking across the table while I write.'[6]

The third room, the door to which was on the right in the kitchen, was the most private of the three, the room where only Lila's dearest friends could enter, and only in truly exceptional circumstances. Its terracotta floor was painted white. Above the bed, which was alternately covered with a feather quilt or a white crocheted bed cover, hung an icon and a few paintings and old drawings. Next to the bed there was a blue cupboard, above which was wall-mounted shelving filled with photos and family portraits.

At the back of the room, in front of the window, there was a large table where Lila worked alone and, in the mansard corner, two shelves where she kept her favourite books.

The cats were only allowed in this room if they were recovering from an illness, an operation or having had kittens, and so when in special need of rest and quiet.

There are only a few images of that apartment, as Lila's reserved nature permitted her friends to take only a few 'stolen' shots, but those three *chambres de bonne* were unforgettable for anyone who spent time in them.

The paintings reproduced here are therefore not only testimony of Lila's love for her cats but also a memory of her private domain and personal universe.

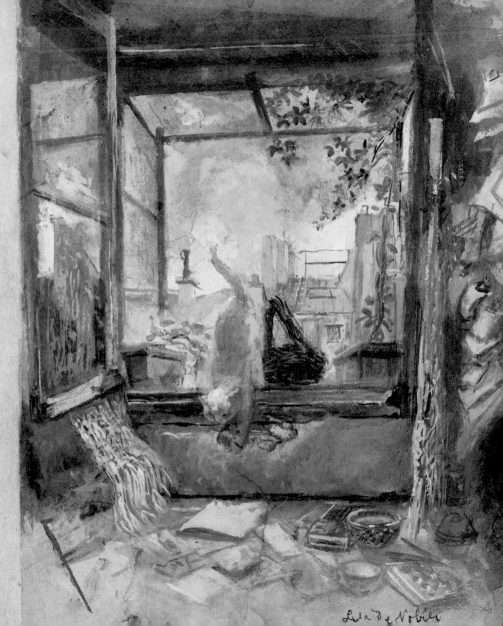

As a thunderstorm broke, Bianco comes back inside, jumping from an open window in rue de Verneuil

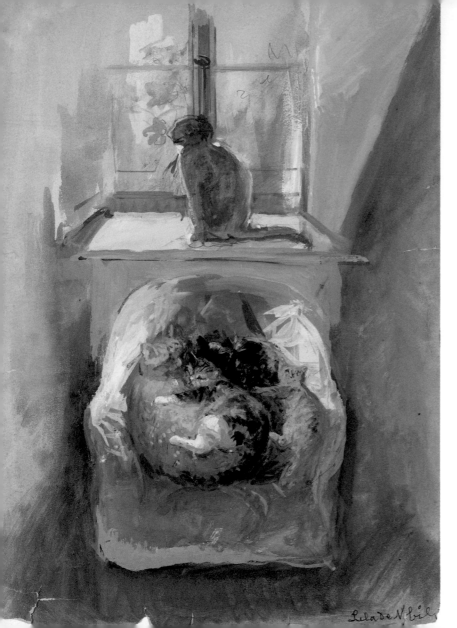

Grisou the Accountant
on the cupboard in the kitchen,
Rouki, Mitzi and their kittens
on the armchair

Opposite page:
Bianco on the windowsill,
Rouki on the cupboard next to
the Neapolitan coffee maker
and Dominique stretched out

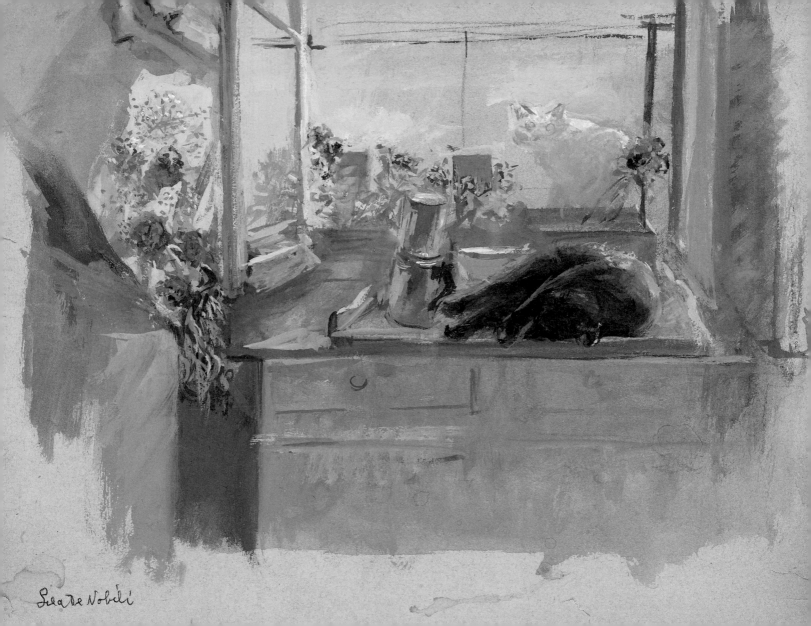

Lila de Nobili

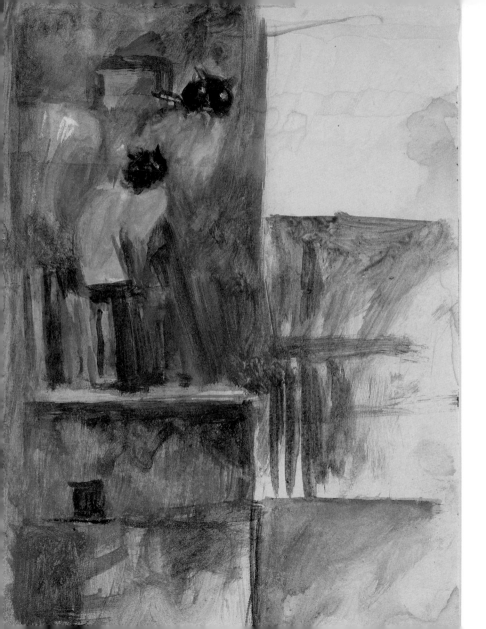

Ulysses and Rodecka keeping
watch seated on the bookshelves
in the kitchen

Opposite page:
assembly of waiting cats

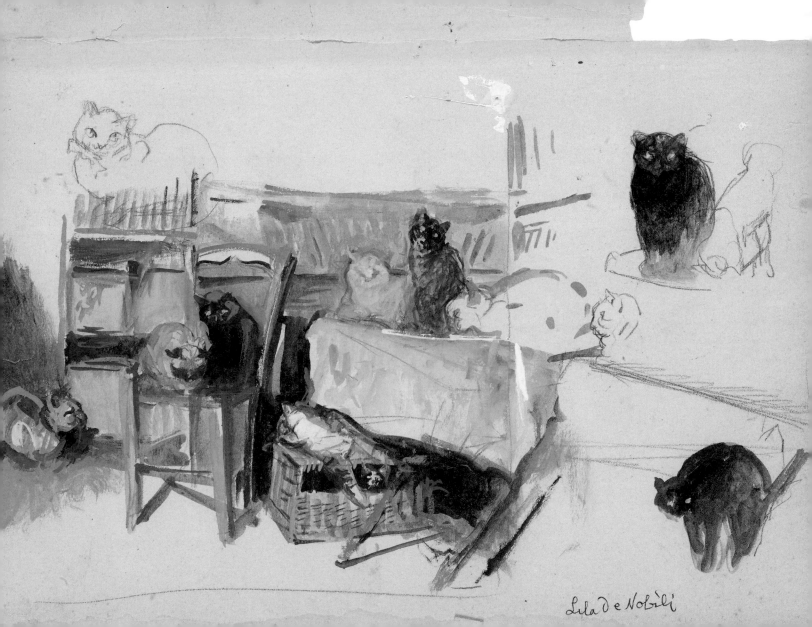

Lila de Nobili

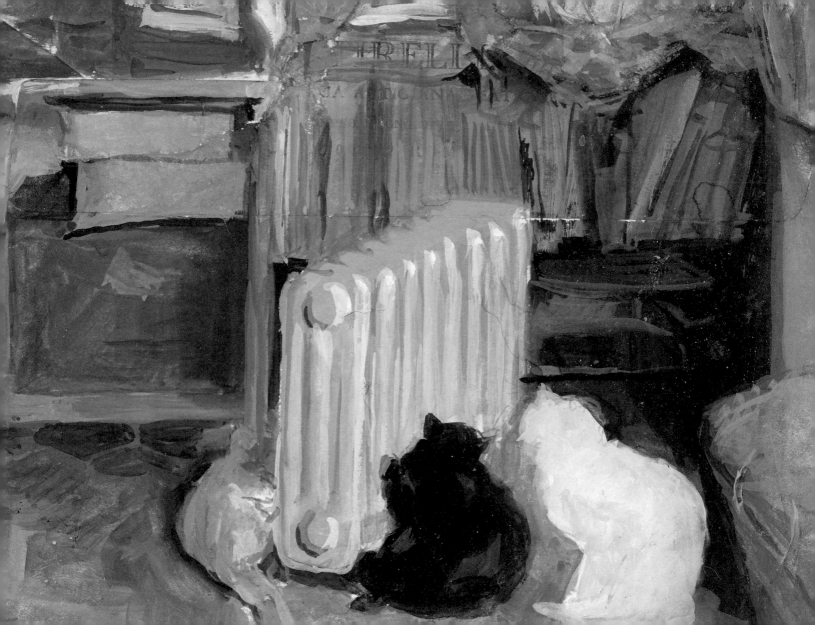

Opposite page: a grey cat,
Dominique and Bianco, warming
themselves next to the radiator

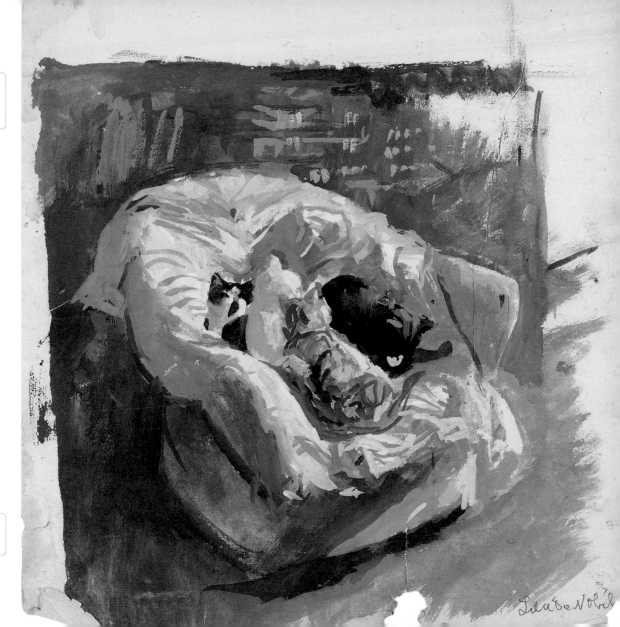

Four kittens on the armchair
draped with a sheet

Bianco and a small tortoiseshell
cat on the shelves amongst
the books; on the left, a sketch
of the same scene; the corner
of the kitchen sink with the
Neapolitan coffee pot

Opposite page:
mealtime; study
of a cat's head

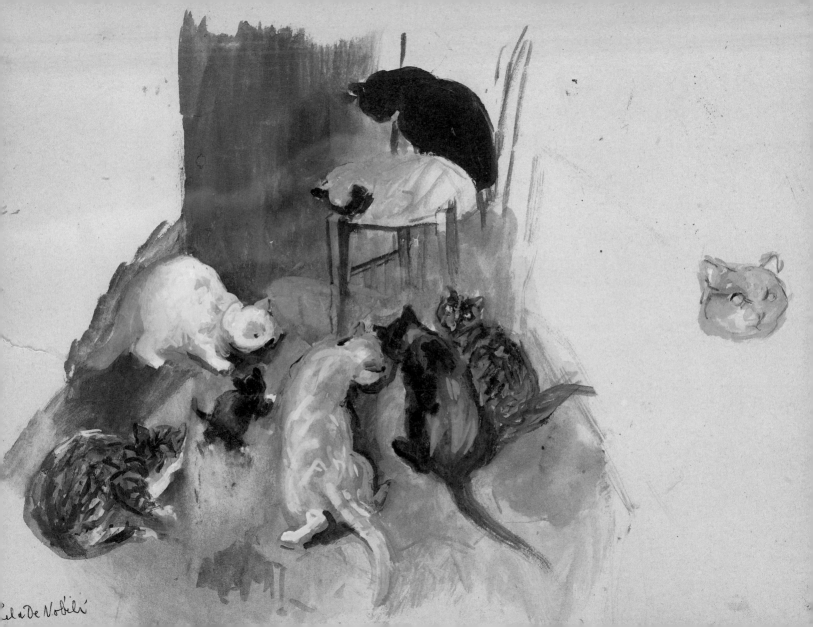

Lila De Nobili

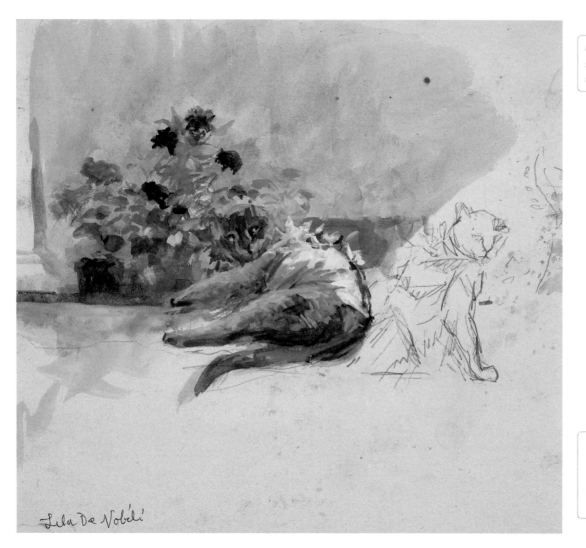

Lila De Nobili

Grisou, wounded
and bandaged up, in the window;
a pencil sketch of Grisou

Opposite page:
Mitzi stretched out in the evening
on the cupboard in the kitchen in
front of the closed window, resting
on a plaster bas-relief

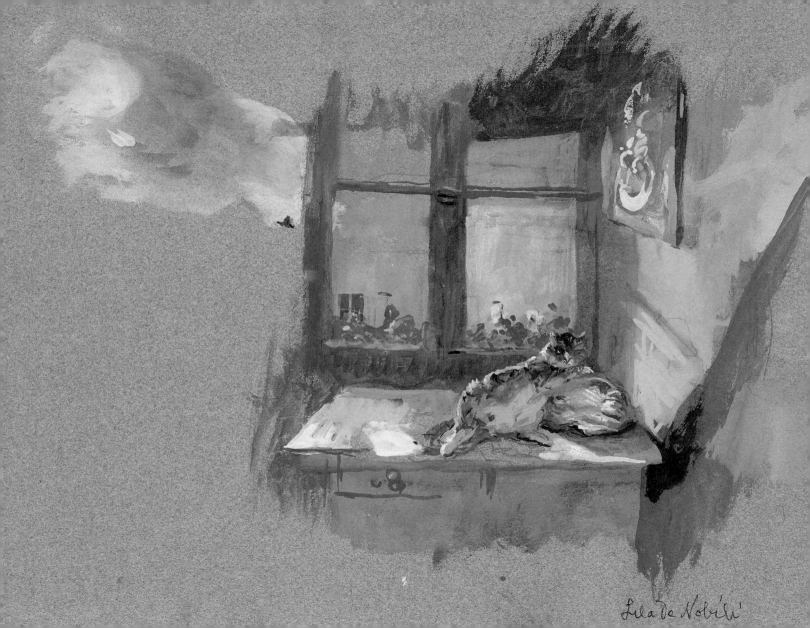

Lila De Nobili

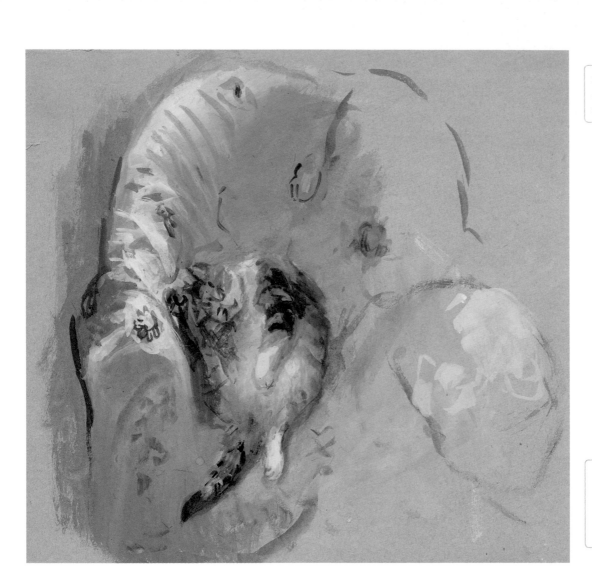

Mitzi sleeping on the armchair covered with a piece of flowered fabric

Opposite page:
Bianco, Mitzi and a white kitten sleeping on the flowered armchair covered with a sheet; four studies of white kittens

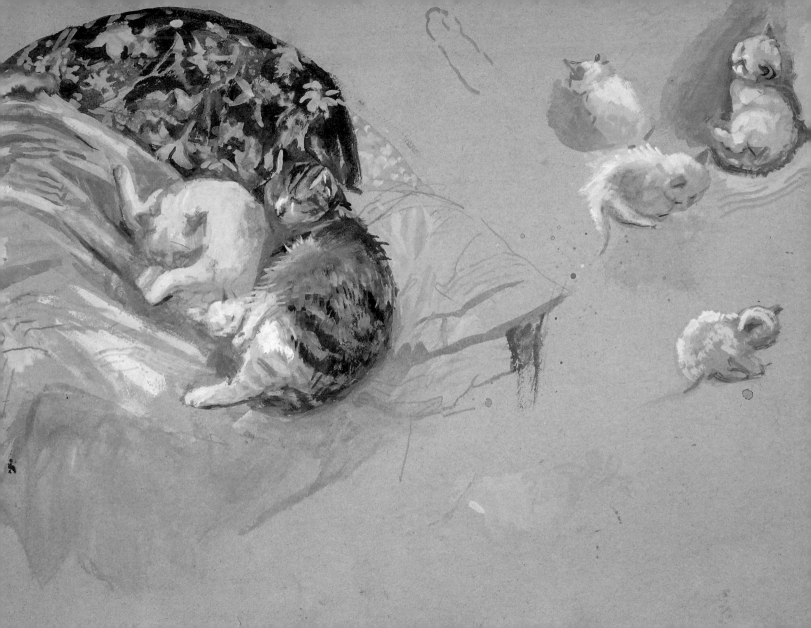

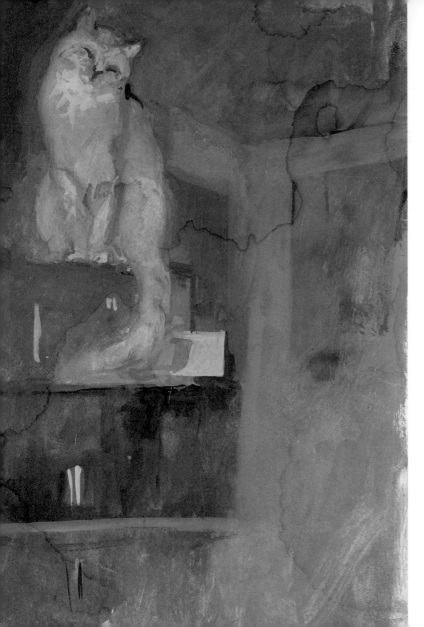

Rouki happy overlooking the scene
from on top of the bookcase

Opposite page:
Mitzi sleeping on a white sheet
of paper amongst the books

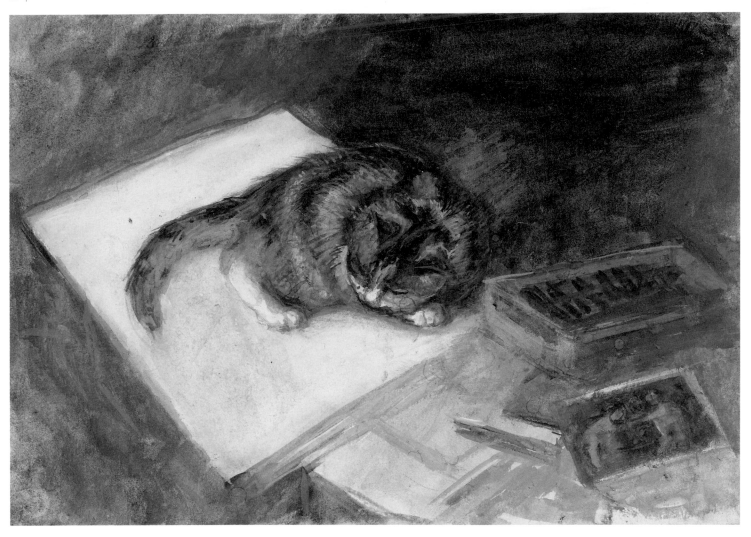

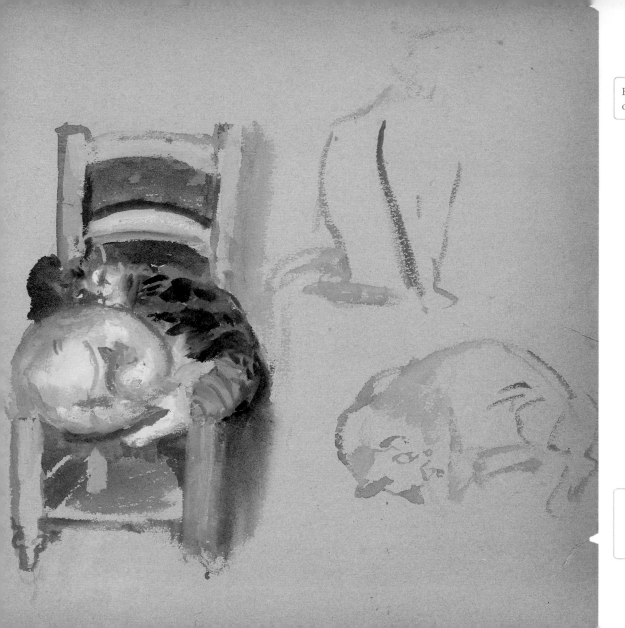

Bianco and Mitzi sleeping
on a chair

Opposite page:
Dominique sleeping on a chair
with a fringed black shawl
hanging over the back

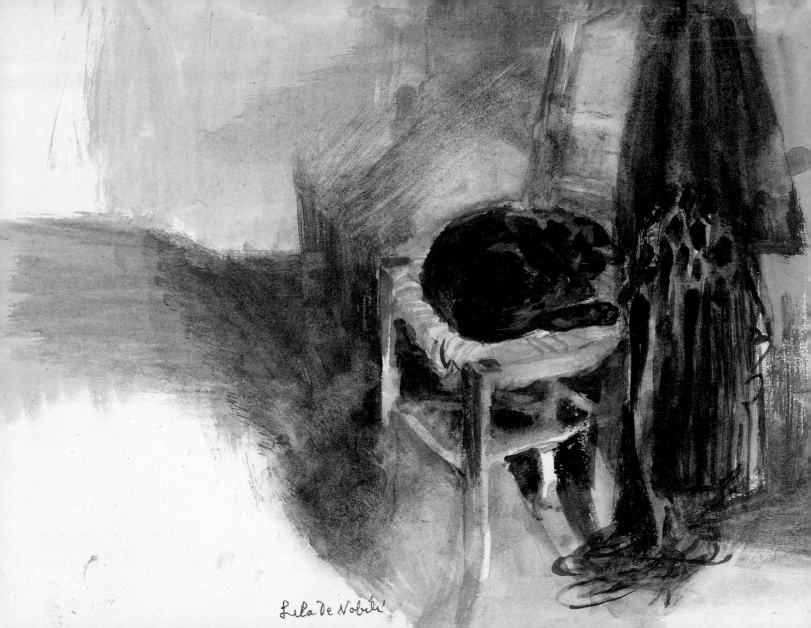

Lila de Nobili

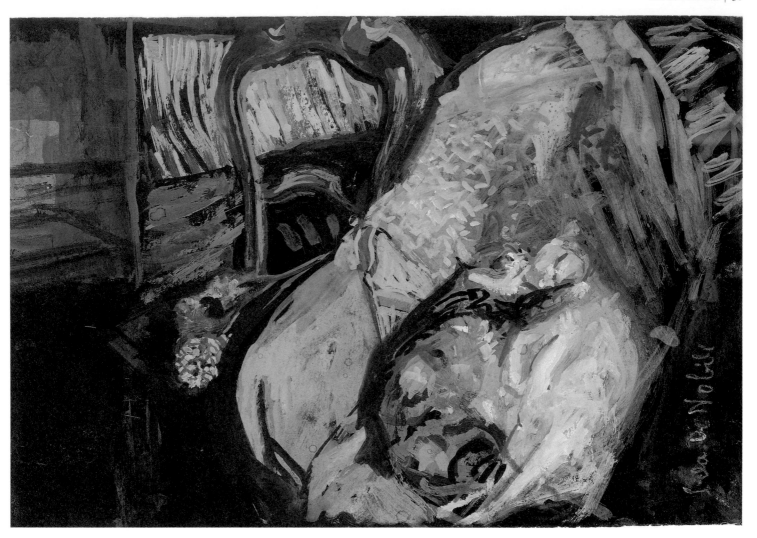

Opposite page: Mitzi and Bianco
embracing on the armchair
in a corner of the kitchen

Mitzi, Aphrosine, Rouki
and Dominique sleeping
on the armchair

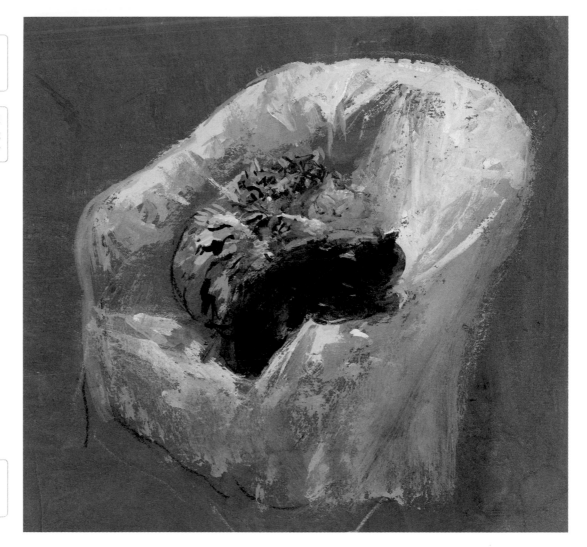

On the following page:
Grisou
in the open window at night

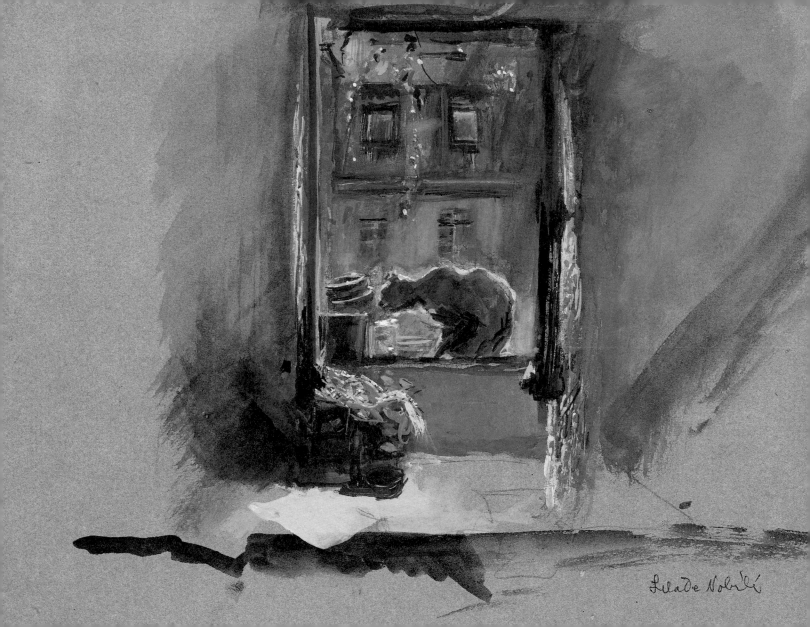

studies and sketches

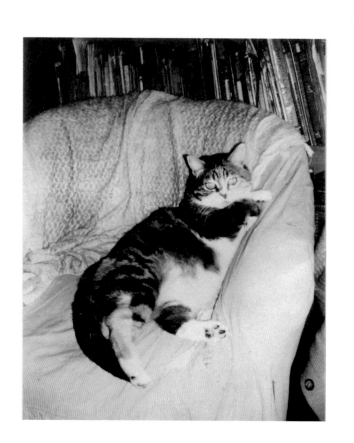

For Lila, all places and all things were worthy of study: regulars at a bistro, street performers, a horse pulling a cart, a cat washing its face, a society lady at the theatre, a bouquet of flowers, a painting at the Louvre.

She made no distinction between the fine and the applied arts: whether painting a portrait or a porcelain plate, what counted were observation, truth and technique.

She had a penetrating gaze equally at home with the character of a person or an animal, and her tribe of cats, created over the years entirely by chance, was not only a family to love and care for, but also an opportunity to have constant access to models, which she could study any time day or night, in a context of intimate domestic tranquillity.

Her dozens of drawings, sketches, drafts and complete portraits of cats were therefore the fruit of years of observing, often with amusement or irony, the behaviour, expressions and poses of the creatures that accompanied her days. The renderings are sometimes just quick sketches, capturing the uniqueness of one of her cats in just a few lines, but more often they are analytic, such as her accurate renderings of the pattern of their spots and stripes.

When she was staying with her friend Christine in England in the early 1980s, to work on a series of chromolithographs, she wrote: 'It is nice to be able to make thousands of little dots without having anything else to worry about. But do I think often of my cats, the little white one who will be taken away and all of this together is a bit painful.'[1]

Her study of old nineteenth-century chromolithographs undoubtedly developed her extremely close attention to detail, for the rendering of the fur, physiognomy and individual expressions of each of her cats.

This familiar world was explored—almost daily, like a painted diary—in particular starting in the early 1970s, when the apartment in rue de Verneuil was frequently visited by Marc-Michel, Lila's model and occasional helper, who, along with his Siamese cat, Ulysses, was staying in a room near the ones where Lila lived.

Ulysses, a traveller like his namesake who came and went with his owner, was soon joined by another Siamese, the graceful Rodecka, and a cache of rescue cats, like Rouki, a ginger kitty with fat cheeks, and Grisou, a terribly ugly but dear cat with a flat face and ears wounded in countless battles who had been rejected by everyone else, a solitary, melancholy feline with a rare intelligence that won him the nickname 'The Accountant.' And then their countless kittens, like the black Dominique, the white one named sim-

ply 'Bianco,' and Mitzi, a tricolour kitten 'with a Renoir face.' [2] Lila carefully studied the character and features of each and every one, like Rosemary's Baby, a black cat 'with a resemblance to Lautrec for those able to perceive his rare intelligence and charm.'[3] In 1980, Lila wrote: 'It would be better not to talk about the cats. They have been up to everything and are (temporarily) fourteen. Fourteen.'[4]

Lila's life was heavily conditioned by the number, moods, personalities and illnesses of her cats. Every trip was complicated, although, as she did write: 'Apparently, the cats were so good and quiet while I was gone that the neighbours wondered if they actually weren't there. The turbulence is therefore caused by my presence: "le parent a toujours tort."'[5]

During that same period, she wrote in another letter: 'The cat situation worsens. I don't dare talk about travel, but I am looking for a solution.'[6] But the solution never came, since Lila was utterly incapable of turning away a lost or abandoned cat. And her decision to 'let nature run its course,' which she considered a form of respect, prevented her from sterilising them for years, contributing to their infinite multiplication.

Her care and empathy for animals is clearly expressed in the same letter, in which she continues: 'Friday evening I went to feed the cats of Gare d'Orsay, and there were three enchanting young *Grisettes*. It is sad, they have the air of boarders in grey uniforms.'[7]

One day, imagining what the cats might think about humans, she guessed: 'They must find our fur-less selves quite ugly!'

Lila respected the nature and individuality of cats, also believing that they were thinking creatures and, not without reason, beings with fully human emotions, joys and pain.

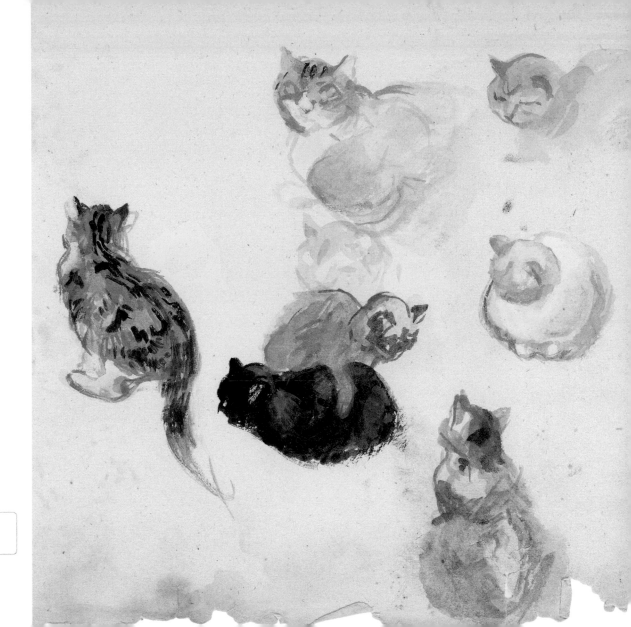

Study of cats, including Mitzi,
Dominique, Bianco and Rouki

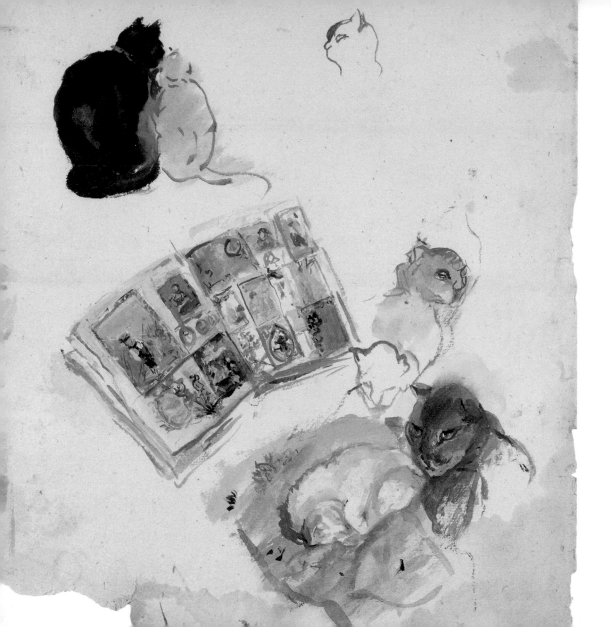

Two cats; a portfolio
of chromolithographs; studies
and sketches of Grisou

Opposite page: seven studies of
cats, including Mitzi, Bianco, the
Accountant, Rouki and Dominique

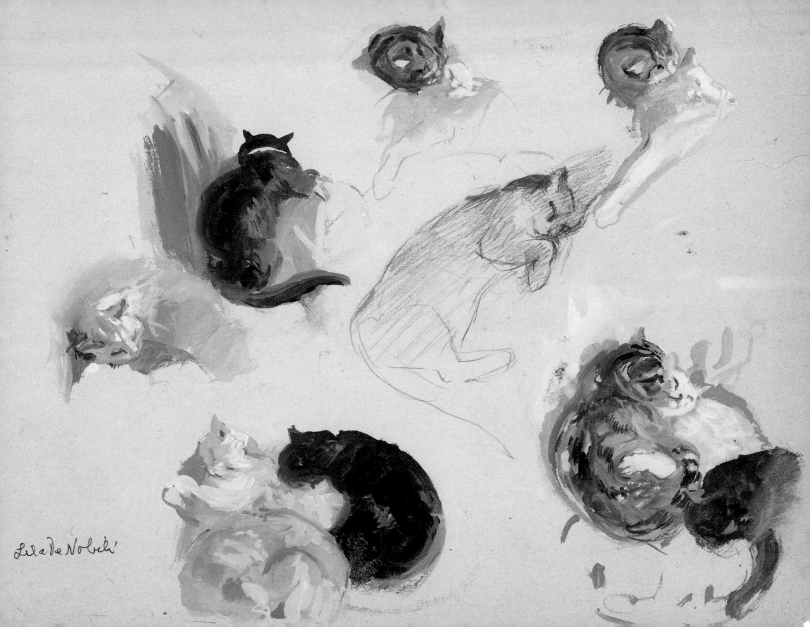

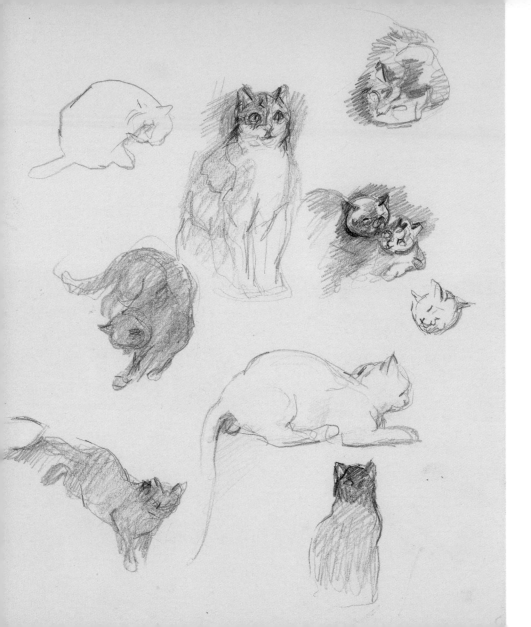

Studies of cats in different poses

Opposite page: Mitzi and Rouki
sleeping amongst the books
near a paint box; studies
of Aphrosine, Bianco and Rouki
in various poses

On the following pages:
on the left, studies of cats;
on the right, eight studies of cats,
including Grisou, Bianco lying on
top of Rouki; Bianco curled up in a
ball; Aphrosine

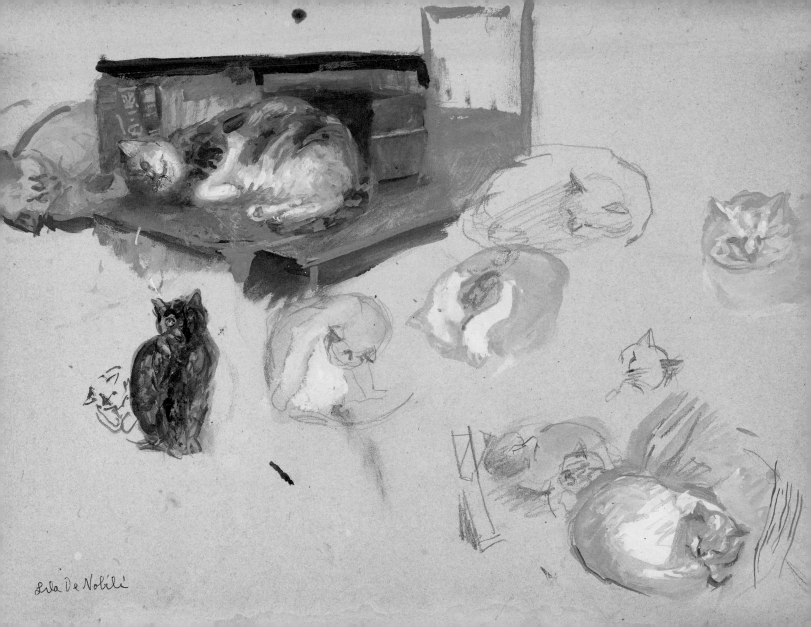

Lila De Nobili

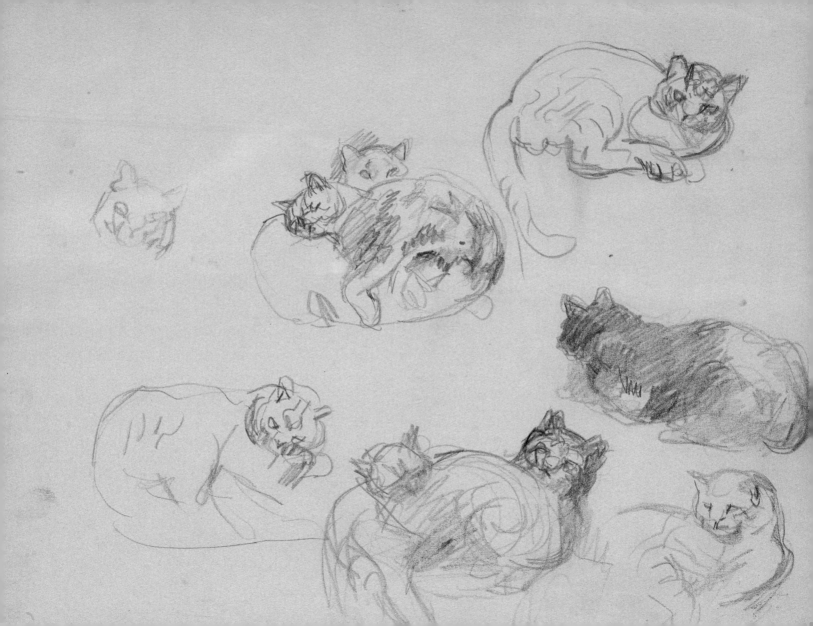

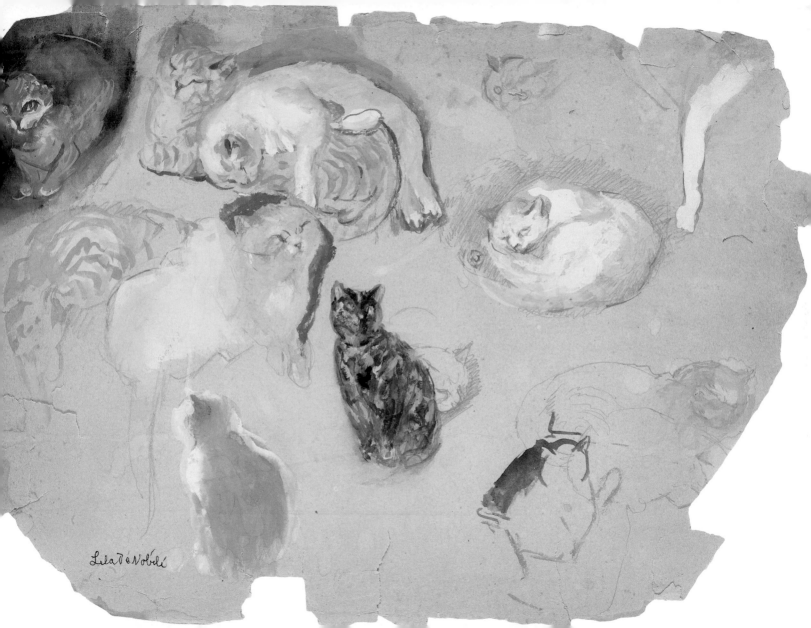

Lila de Nobili

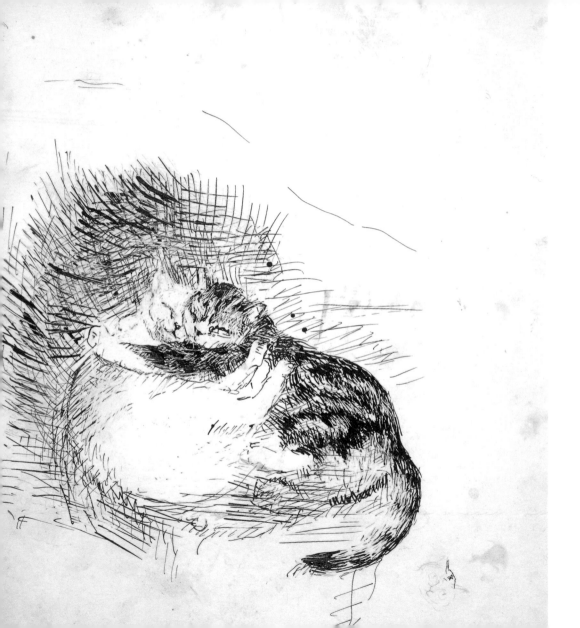

Bianco and Mitzi embracing
on the armchair

Opposite page:
study of a black cat observing
a group of other cats

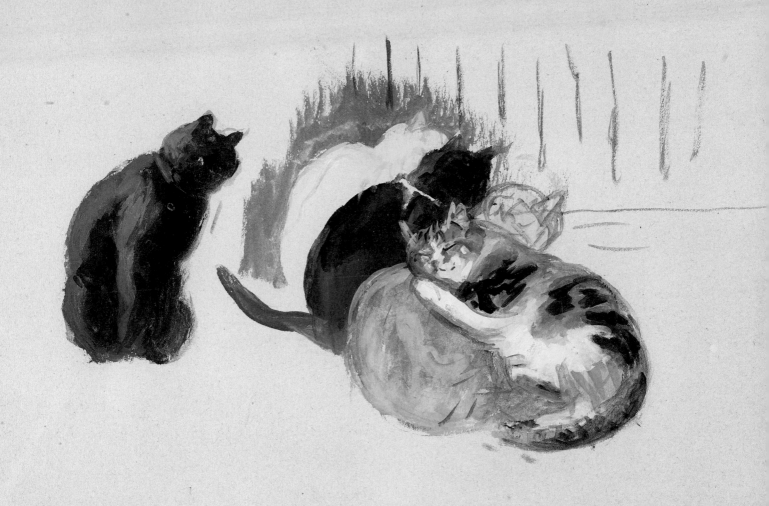

Lila deNobili

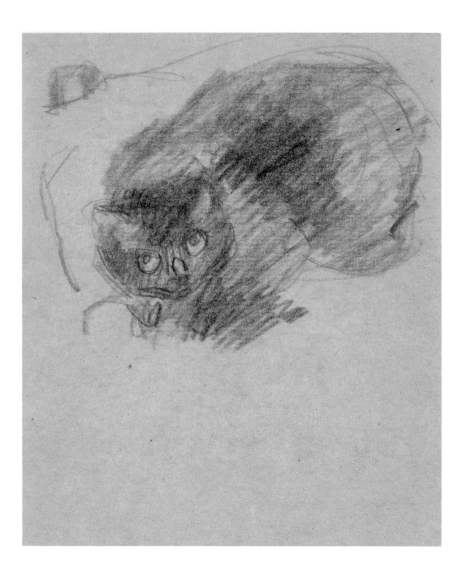

Sketch of a black cat

Opposite page:
two studies of Nana,
the tabby cat of one of Lila's
closest friends, Jean-Marie Simon

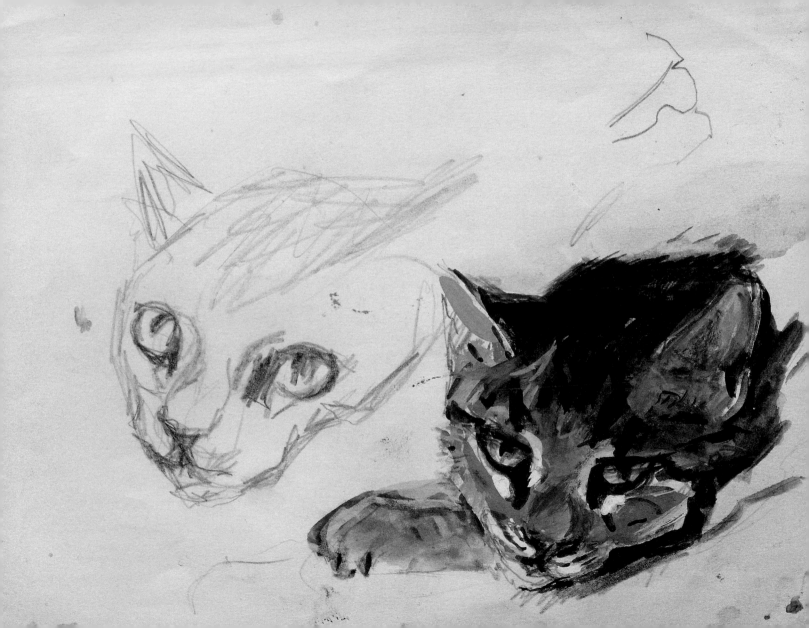

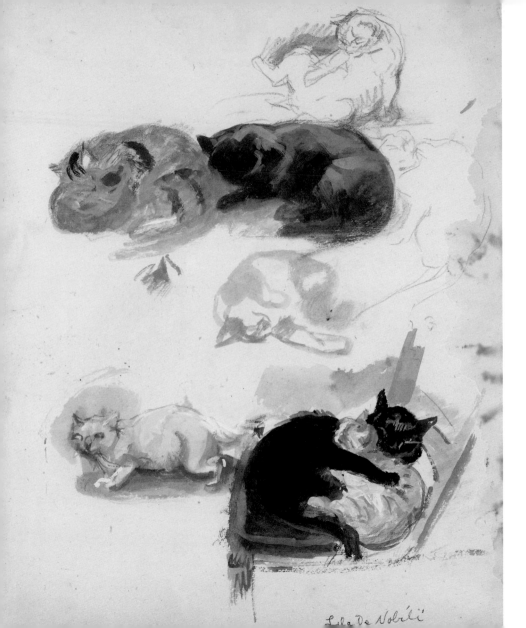

Lila De Nobili

Studies of a tabby cat
with Dominique, a small
white cat and again Dominique
on a chair, embracing
a ginger cat

Opposite page:
group of cats with a mother cat
nursing her kittens

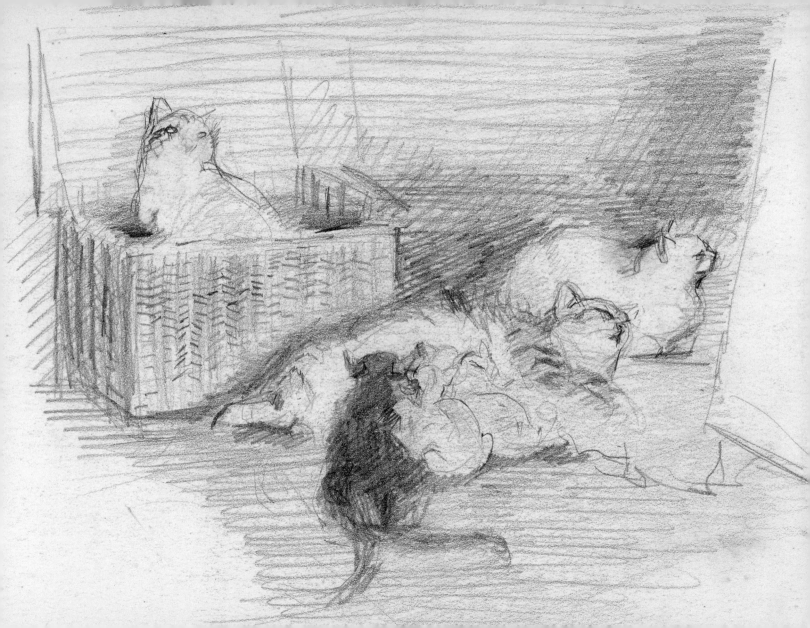

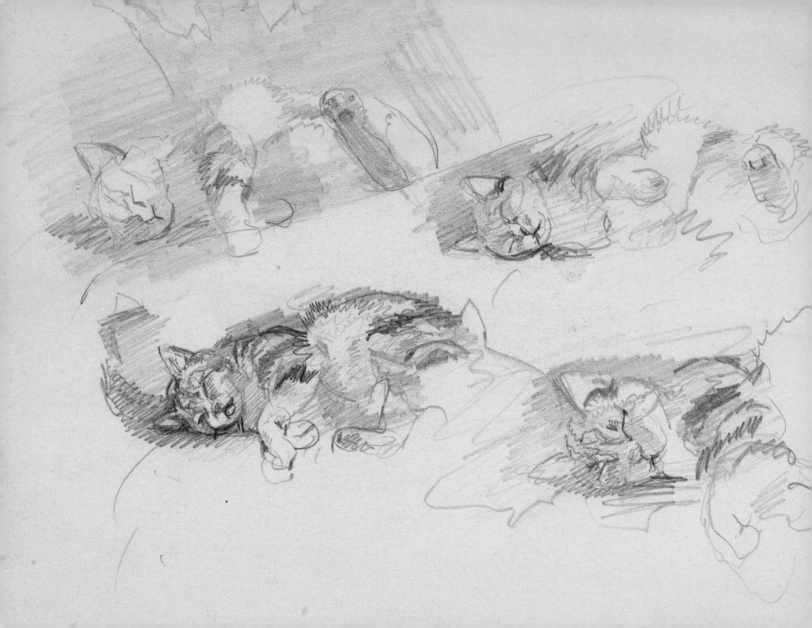

Opposite page:
studies of Mitzi sleeping

A few studies of a tabby cat, one
with the pattern of its markings

On the following pages:
on the left, study of a family
of cats on the eiderdown;
on the right, studies of Mitzi
and Bianco embracing
and of Dominique looking at them
from above

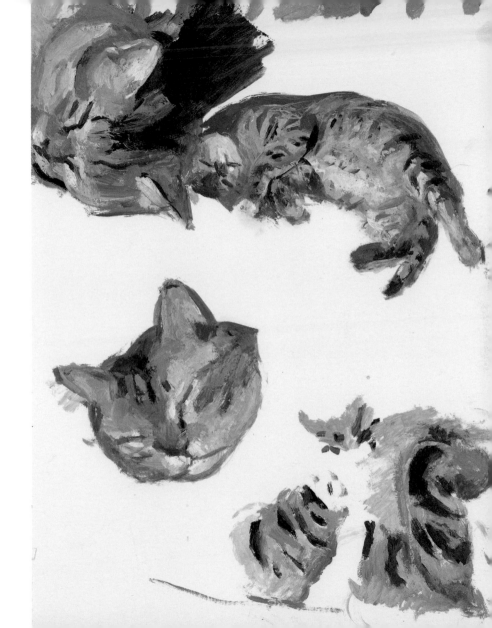

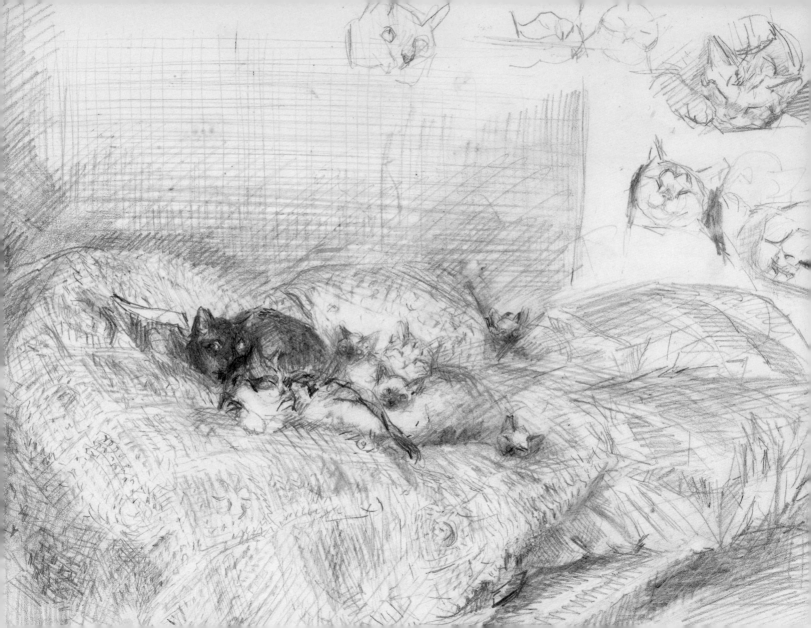

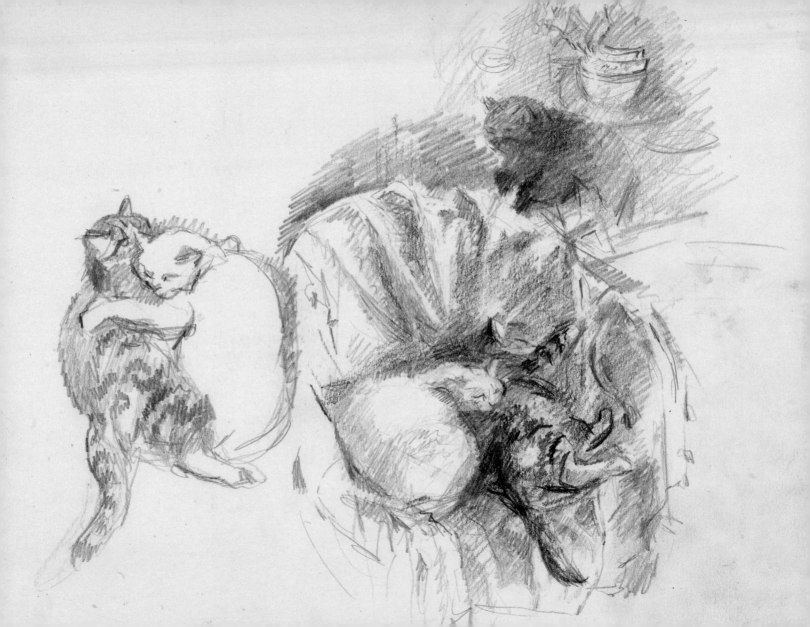

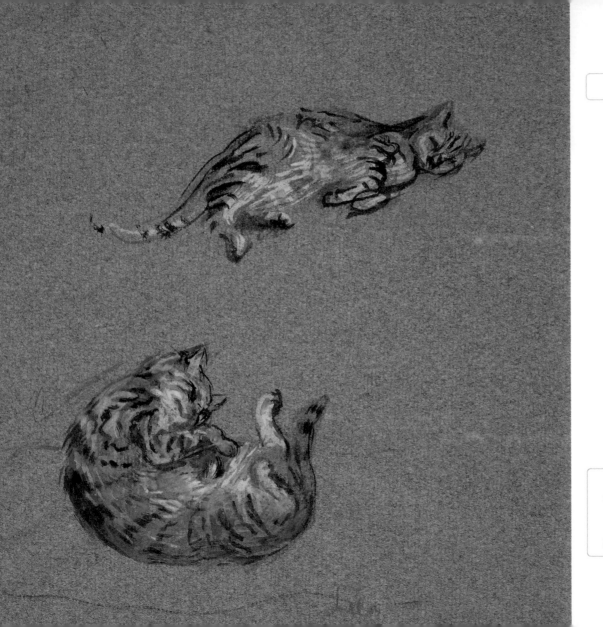

Two studies of the cat Radamès

Opposite page: a tabby cat and
Rodecka with a crown of flowers;
Rodecka, a tiger-striped cat
and Ulysses; two kittens;
Dominique with a jewelled collar

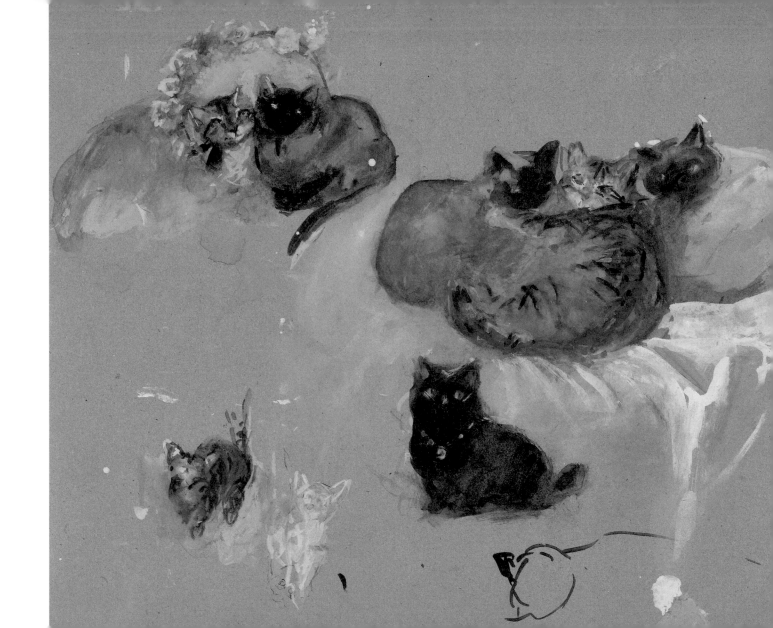

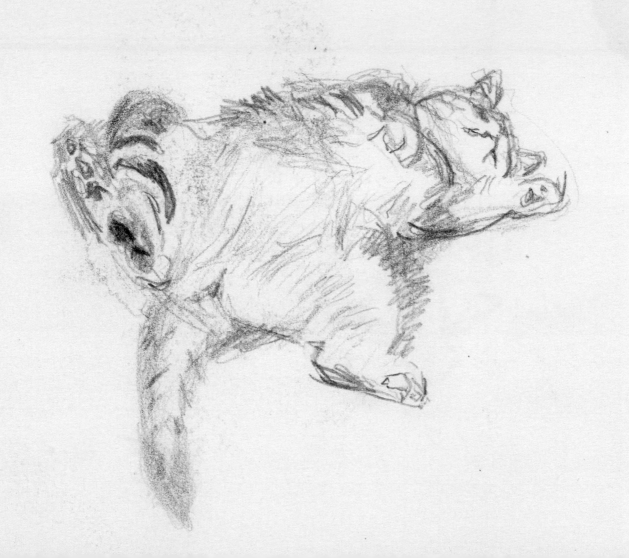

Opposite page:
Studies of Mitzi sleeping
on her back

A rapturous Mitzi

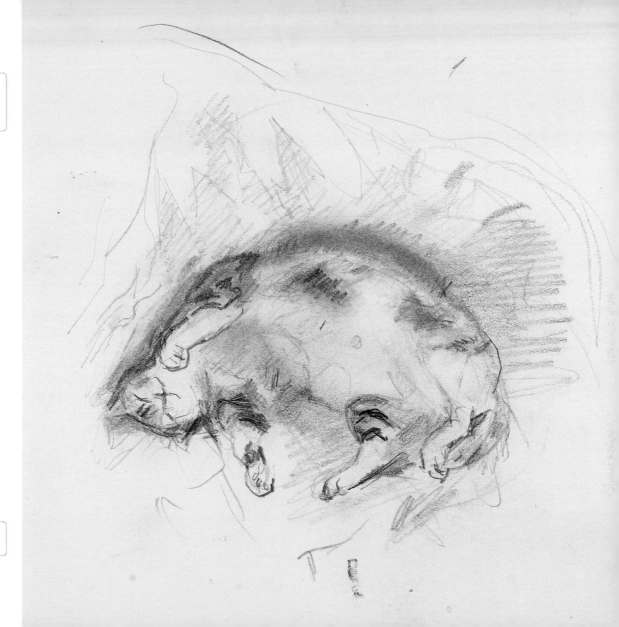

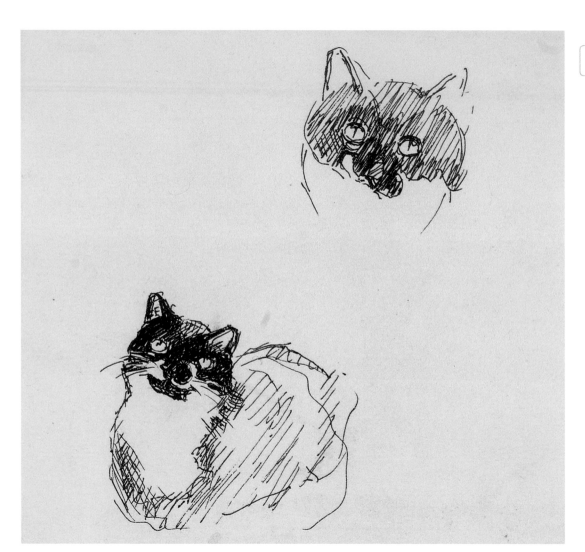

Studies of a black and white cat

Studies of a black and white cat

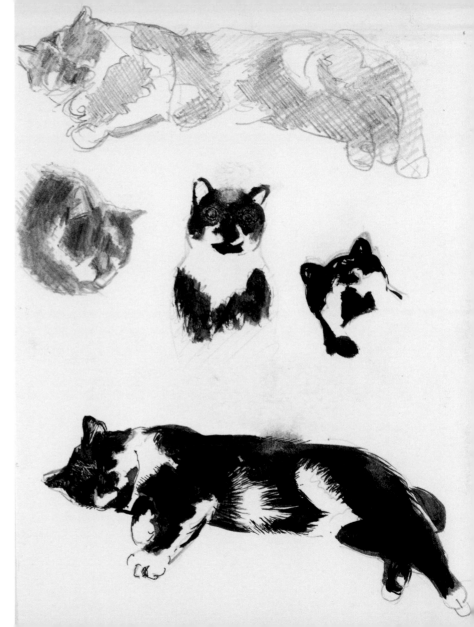

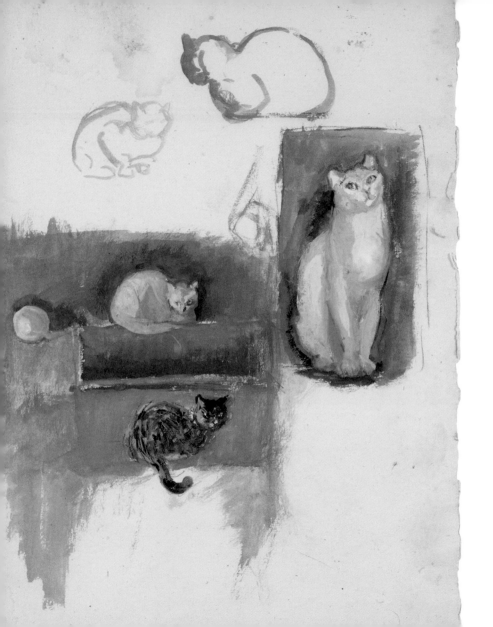

Studies of cats,
including Bianco
and Aphrosine

Opposite page:
study of Affreusine/Aphrosine
with a note written by Lila:
*Affreusine 'the convalescent' at
the Peker clinic. Happy New Year*

Alfreusine "La Convalescente"
à la Clinique Peter Bonne année.
Lica De Neu

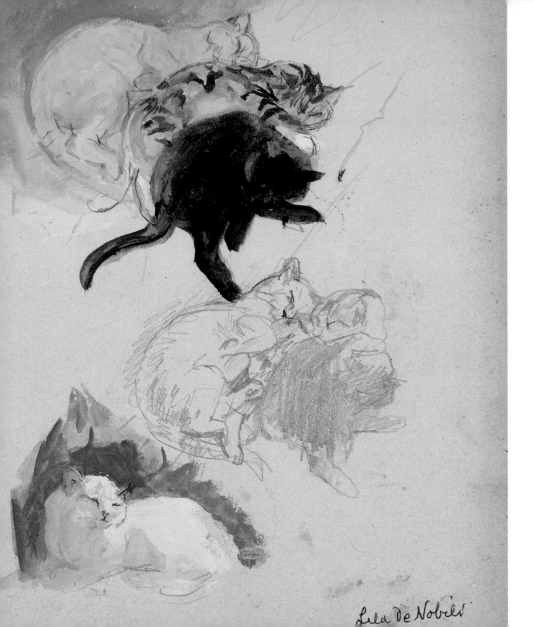

Lila De Nobili

Above, Rouki, Mitzi
and Dominique; middle, a study
of the same three; below, Bianco

Left: Ulysses, Bianco and Mitzi;
on the right: study of a cat who
seems to be smiling, sketches of
female heads and an icon

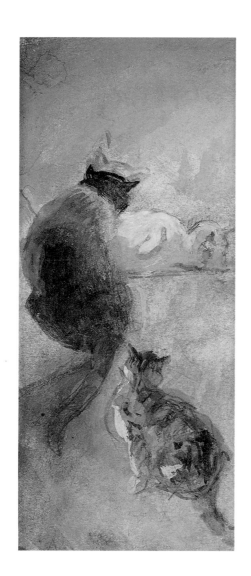

On the following page: studies
of cats. In the middle, a portrait of
a small black and white cat sitting
in a basket that Lila used as a
handbag, with the following note
written on the back: *Memories
of a Well-Brought-up Young Man*

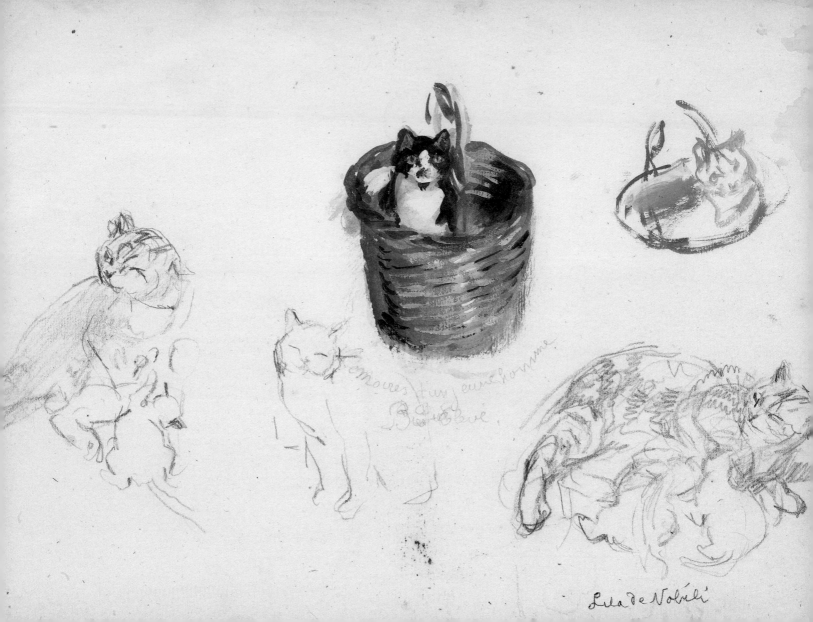

portraits

*L*ila's first real painting attempt was a portrait of a cat that she made when she was around eight years old, its subject a tiger-striped kitty that her uncle Vertès kept with him as a good luck charm. Lila's love for cats also turns up in a letter written as a child by her friend Renzo Mongiardino, who was the same age, to his mother: 'Dear Mama, yesterday we went to Righi, "the land of cats," on a funicular with Lila […] we could see all of Genoa. We ate some ice cream and Lila had milk and gave almost all of it to six or seven cats standing around her.'[1]

Lila had her first cat in the 1940s, a white angora called Nana, who, together with a dachshund named Baron, were with her and a comfort during the difficult times of war. Nana was perhaps one of those cats that, as she jokingly described her friend Salvatore Russo's Persians, 'inspire a bit of awe, and around which one is always afraid of breaking protocol.'[2]

Lila had other cats after that, but it was not until the 1970s, when she stopped working for the theatre to devote herself entirely to painting, that she created a true feline family for herself. Faced with a steadily increasing number of new arrivals and kittens, She tried to find them homes, accompanying her free-kitten announcements with accurate portraits that she posted in local shop windows and at her bookseller friend's shop in Place des Vosges. When given to people within her close circle of friends, Lila liked to hear news of the cats and make portraits of them, even years later. Sometimes she wrote letters addressed to the cats themselves and accompanied by drawings. One example is of a letter to Lola, a descendent of her cat Mitzi, who was in the habit of going into the neighbour's house: 'Dear Lola, I have never made a portrait for you because you have never sat for one. This is therefore not a true portrait, but the colouring of your spots and most importantly your position behind a closed window [the neighbours'] seems right to me.'[3]

Whenever one of the cats died, it hit her very hard, as in the case of Mimì, one of the first in her tribe, 'poor Don Quixote, who, in an attempt to break up a fight between two other cats (obsessed with defending the oppressed and enforcing justice) fell off the roof and died right before my eyes.'[4] Or, talking about the death of her beloved Dominique: 'I suffered so much over Dominique. It was so violent and terrible. (…) I try not to think about it too much, but sometimes I avoid the kitchen because I know that his sturdy little black self will not be there. In the end, the thing that hurts most is the memory of a creature's weaknesses, ambitions and strengths.

I am not being silly, you have cats so you understand. He talked all day long: poses, threatening voice, everything was studied, just when he was in his favourite spot, stretched out on the arm of the armchair, his big head resting on his folded paws, eyes open, thinking and contemplating his world.'[5]

'I see him everywhere (…) staring into space or dreaming, with his black coat and a jewel. He was Rodecka's kitten and the smartest and most interesting of all, perhaps the centre of that miserable little world, as if he were aware of a great sadness.'[6]

In 1991, she wrote: 'The little rescue cat is a consolation. It takes a bottle—it should already be weaned—with a furious, bacchanal passion. Wearing the red ribbon and bells that Jessica put on him so that he wouldn't be stepped on, he looks like an advertisement, a chromolithograph, over-the-top.'[7]

Her attentive and compassionate empathy, along with her benevolence towards especially fragile creatures, made it possible for Lila to create portraits of the cats that were not just physiognomically accurate but also captured their whole individual personality. It also influenced the way she chose their names, one example being a little tortoiseshell cat who seemed to come out of a painter's mad palette and was so strange that at first she was called Affreusine ("Little Awful One", from the French *affreuse* = dreadful) but as she revealed her comic charm, this name was corrected to the more amiable Aphrosine. Or, in a sadder example, Lila seemed to predict the fate of one cat when he was born, naming him Innocent, a shy, frightened cat who died young (just like the newborn 'illegitimate son' in D'Annunzio's novel and Luchino Visconti's final film). A name that was also his destiny.

In 1997, in order to help a friend identify the cats in the gouaches she had given her, she replied: 'I absolutely agree with you about identifying the "models and moments." I have spent evenings and mornings writing names on the backs of all of the photos that I have stacked in a pile. Especially cats and dogs … when I meet the intense gaze of the cat Lila Malatesta, it always fills me with emotion and I don't want any of them to remain anonymous.'[8].

Looking for homes for four two-month-old ginger kittens; one black cat with green eyes; one flame-point white Siamese; one very gifted four-month-old black cat / Contact De Nobili, 16 rue de Verneuil, 75007 Paris. This is one of the portraits of kittens that Lila painted when trying to find them a home and posted in neighbourhood shop windows. Also see below, pp. 82–83

DONNE 4 Chatons Roux 2 mois DONNE

Siamoise Blanche 2 mois
orange Pointed

S'adresser : De Nobili
16 Rue de Verneuil 75007
Paris

VOIR YEUX VERTS NOIR 4 MOIS SURDOUE

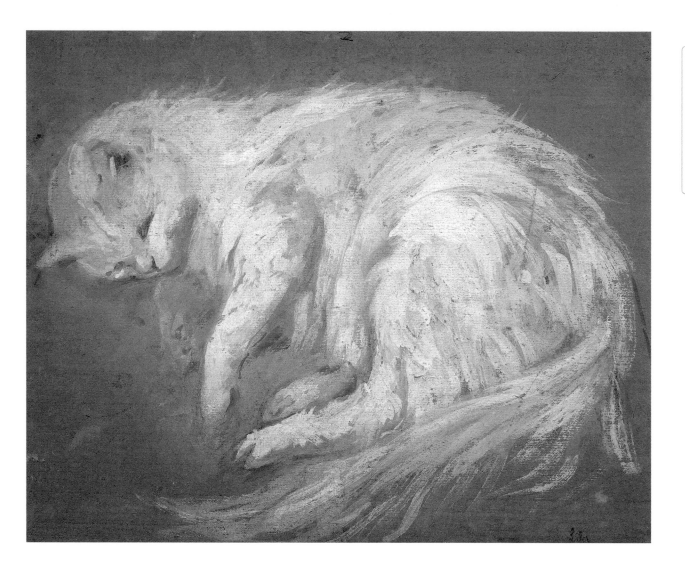

Portrait
of Nana

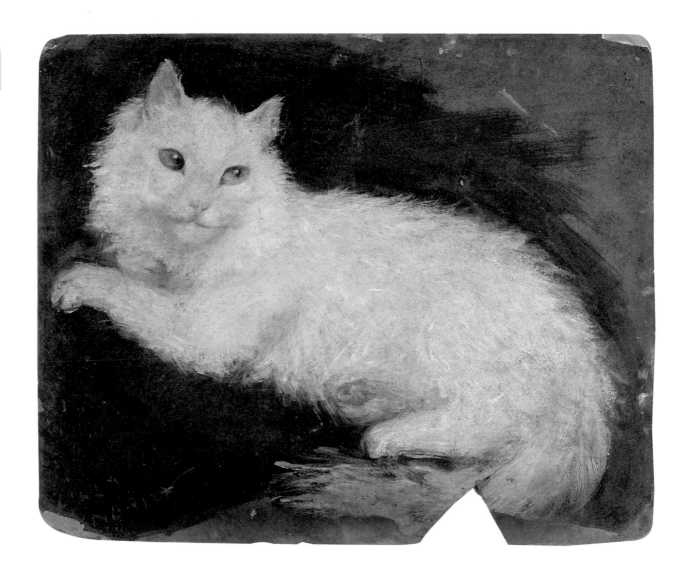

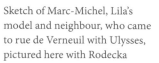

Sketch of Marc-Michel, Lila's model and neighbour, who came to rue de Verneuil with Ulysses, pictured here with Rodecka

Opposite page, on the left: Ulysses arching his back; on the right, sketch and portrait of Ulysses wearing a collar

On the following pages:
p. 80: on the left, portrait of Olimpia with a cat; on the right, Giuliano and Rouki's smiles
p. 81: Dominique, Grisou and Rouki

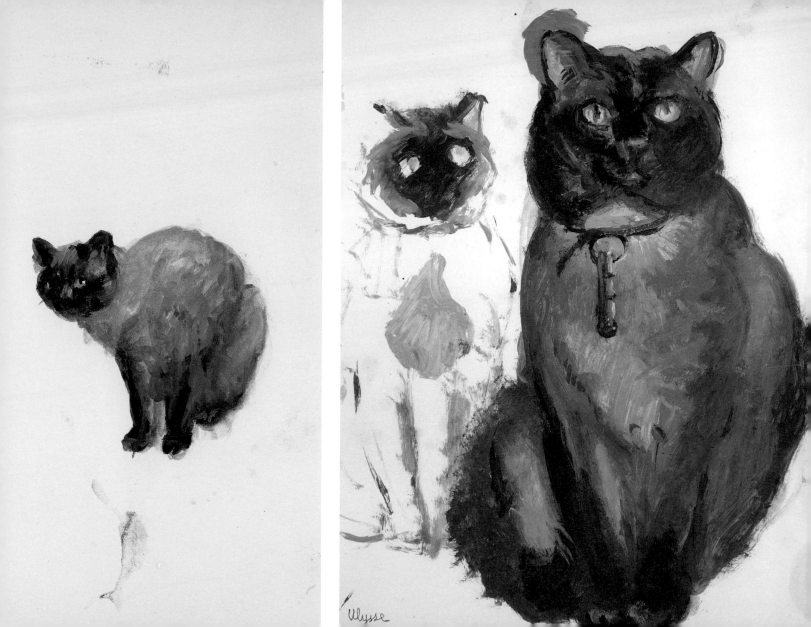

Ulysse

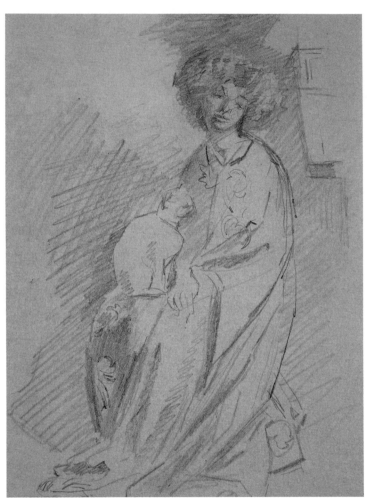

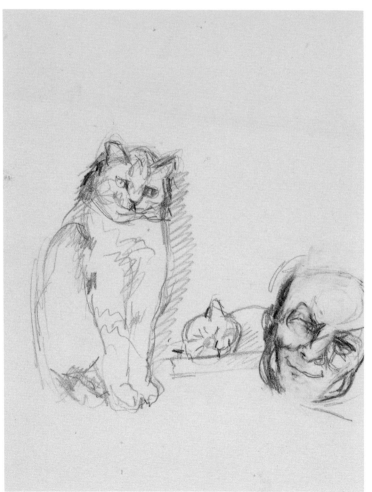

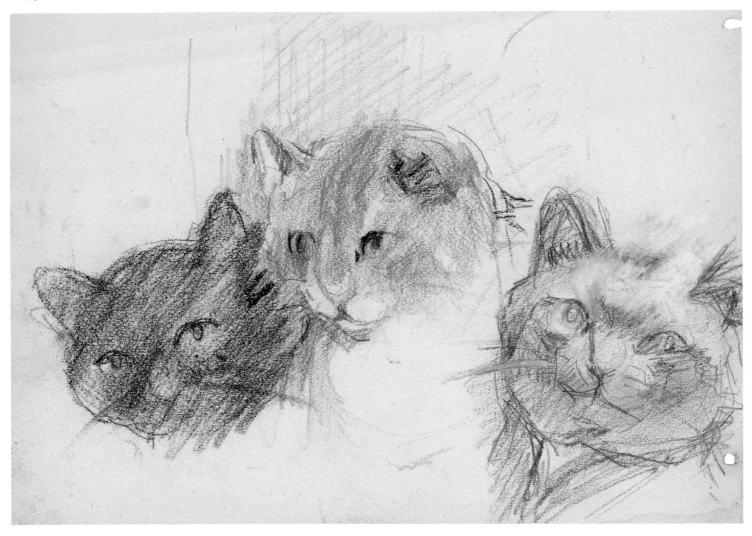

Donne
Chatons tout age, toutes couleurs, (De Nobili)
16 Rue de Verneuil
75007 Paris

Opposite page: *Looking for homes for kittens of various ages and hues; (De Nobili) 16 rue de Verneuil, 75007 Paris*

Looking for a home for three kittens born to Sir Rouki and Lady Mitzi

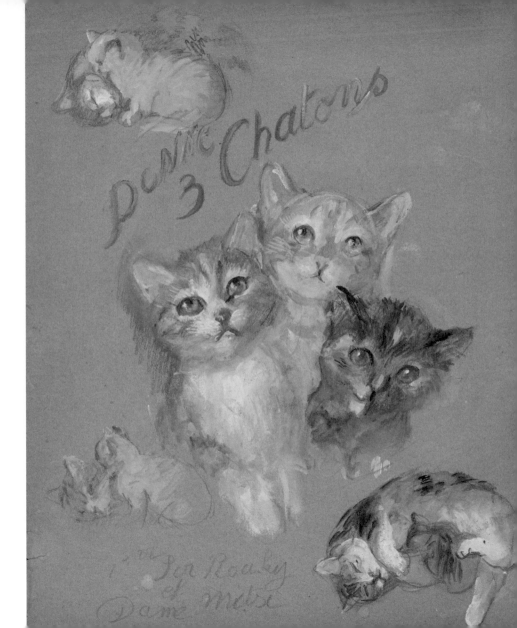

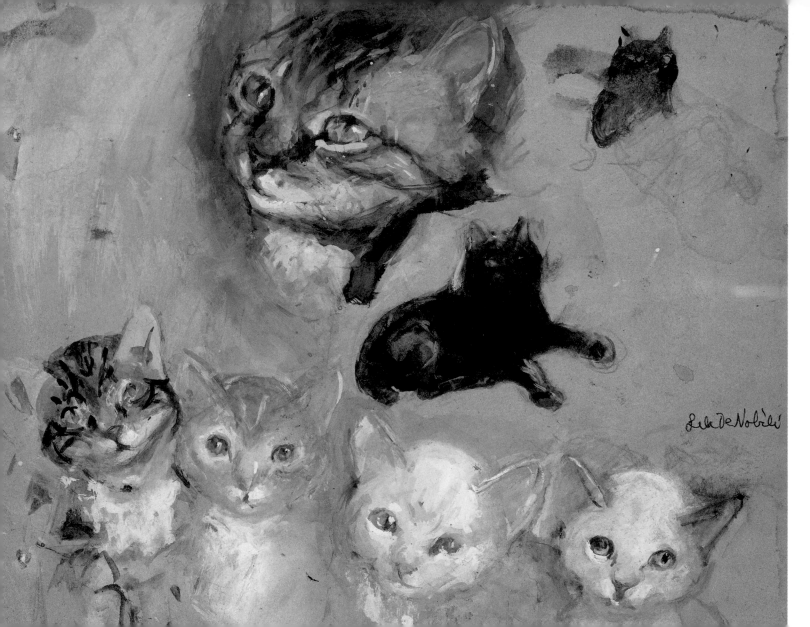

Opposite page: portrait of a young
tiger-striped cat with a purple
ribbon; two studies of a black cat;
portrait of four kittens

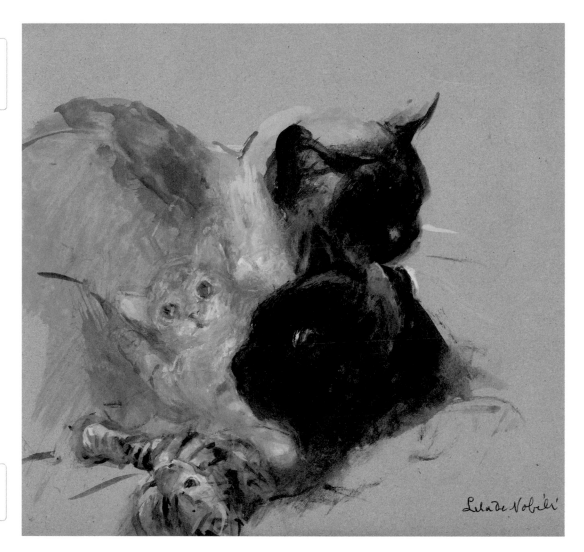

Rodecka the Siamese, Dominique
the black cat, a small ginger cat
and a small tabby cat

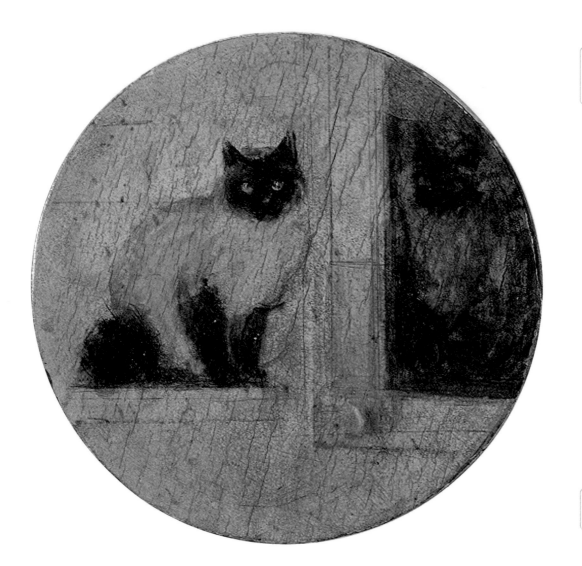

Rodecka seated and reflected
in a mirror, painted on the lid
of a wooden box

Opposite page: study of a rose and
portrait of Rodecka

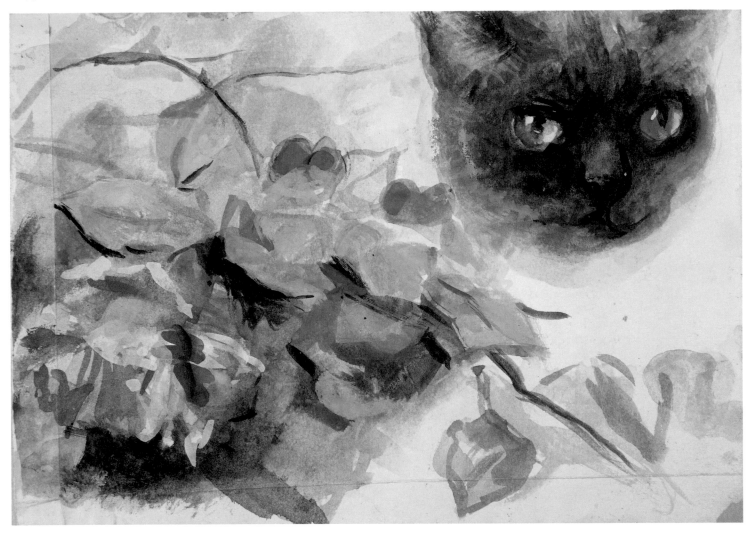

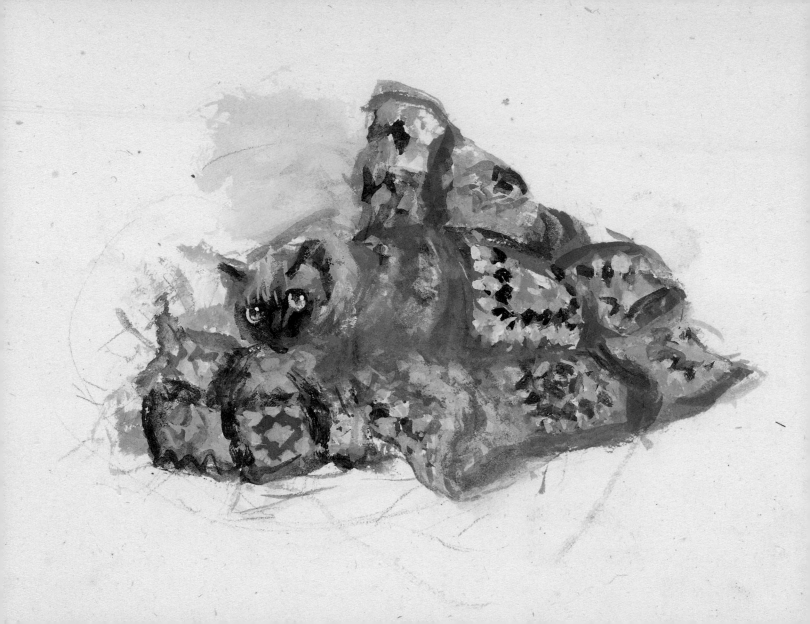

Opposite
page:
Rodecka
wrapped
in a crocheted
blanket

Rodecka unwell,
under
the covers
in a cardboard
box

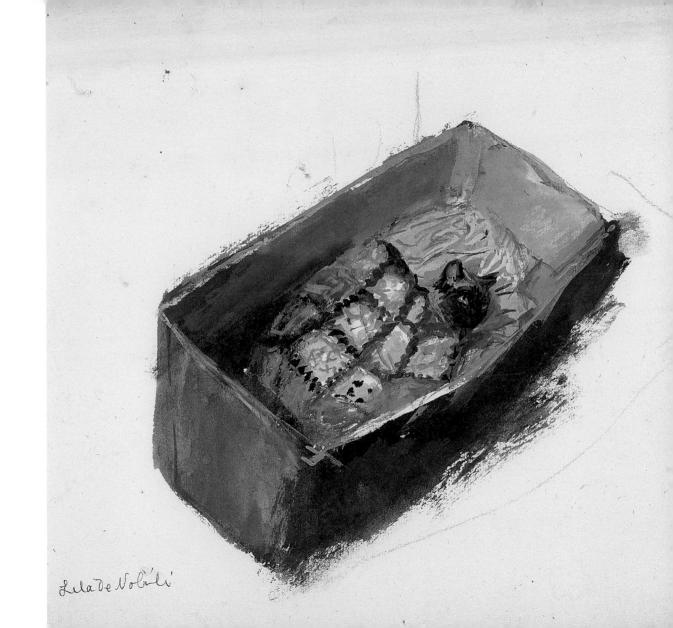

Lila De Nobili

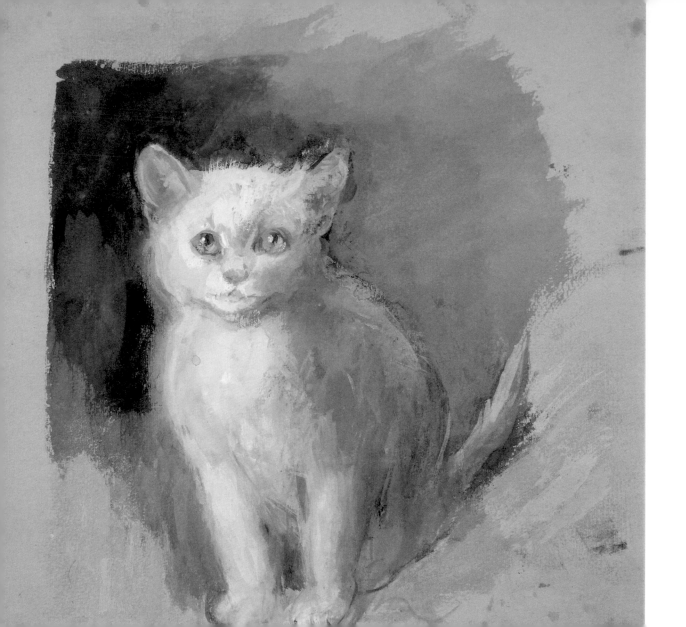

Opposite page:
L'Innocente, a small Siamese

A small black cat
looking curiously at
a large tabby cat

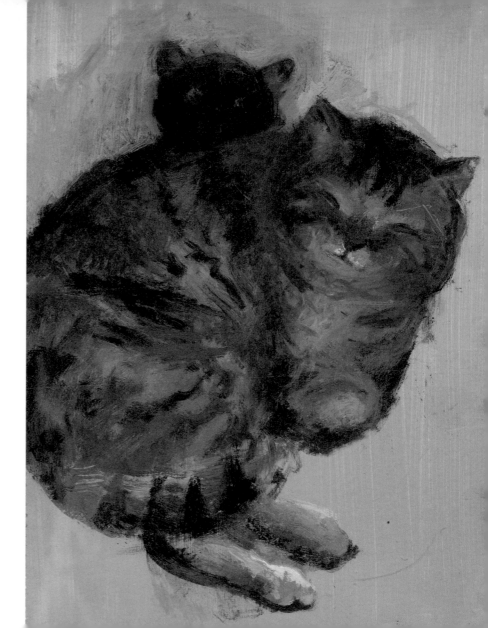

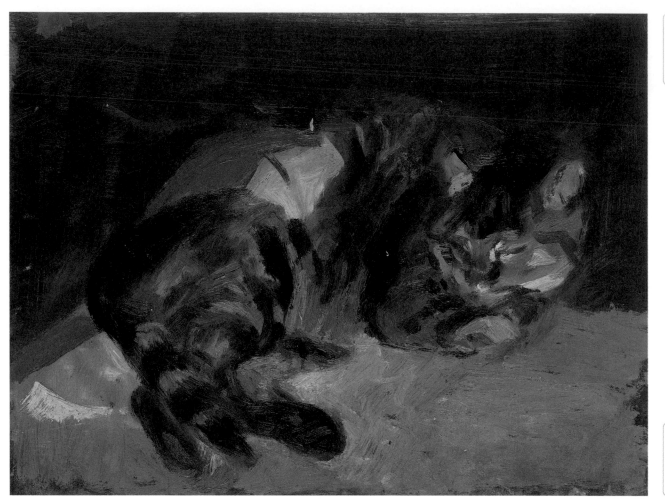

Mitzi
bandaged
up after an
operation

Opposite
page:
portrait of
Mitzi

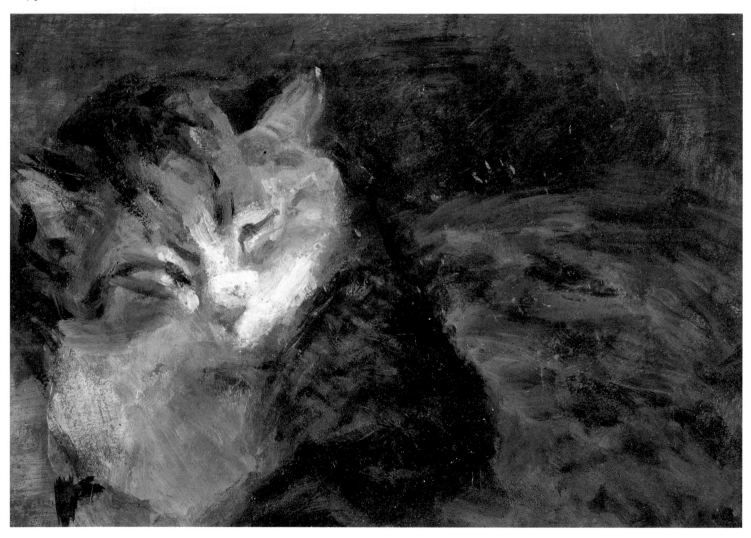

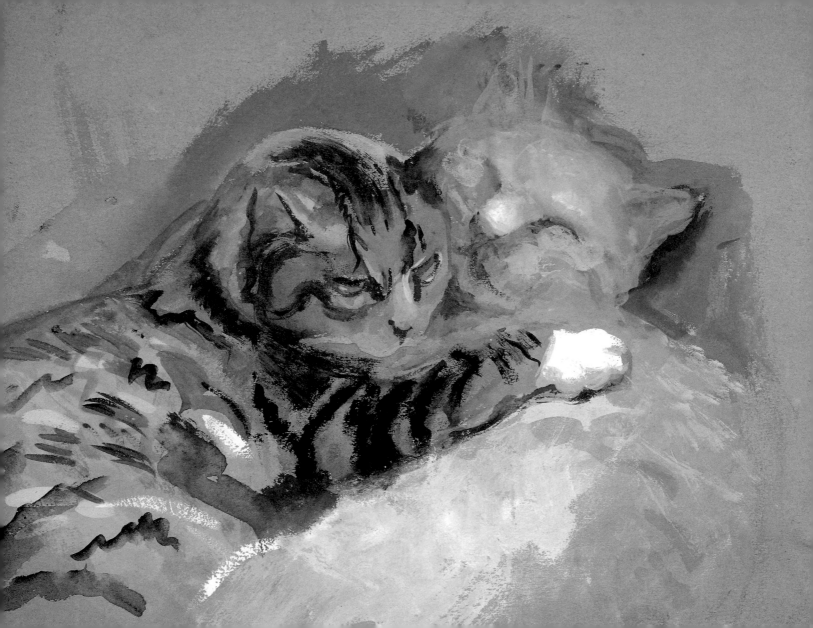

Opposite page:
Mitzi and Rouki embracing

Rouki curled up with a tabby
kitten; Rouki cleaning
the kitten

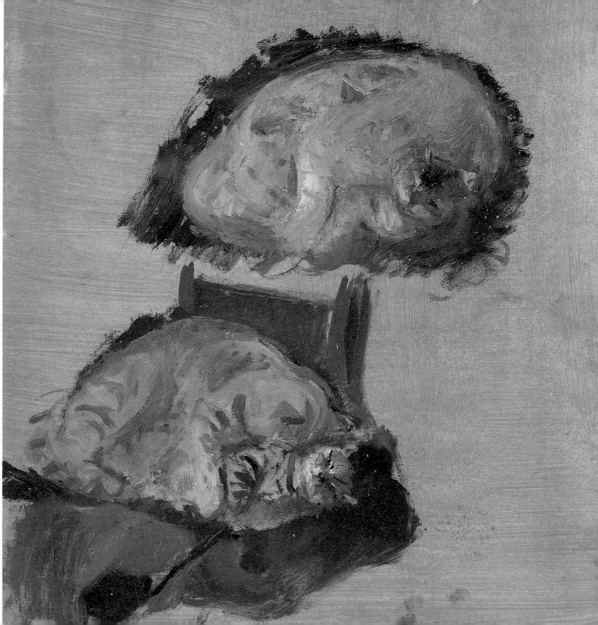

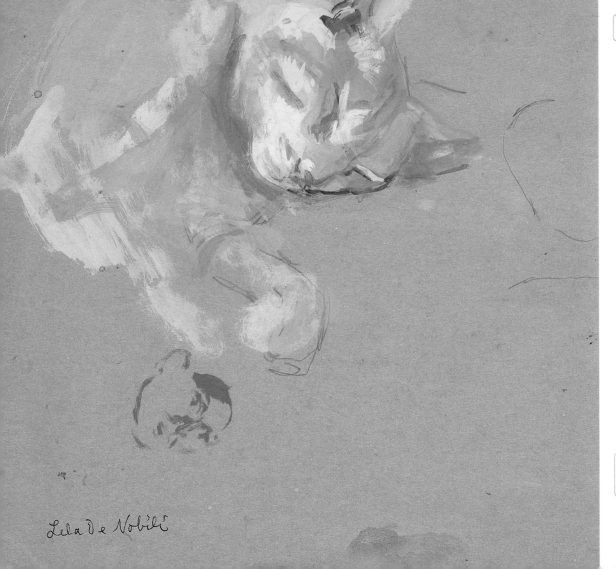

Lela de Nobili

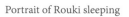

Portrait of Rouki sleeping

Opposite page:
Melampo, a friend's cat

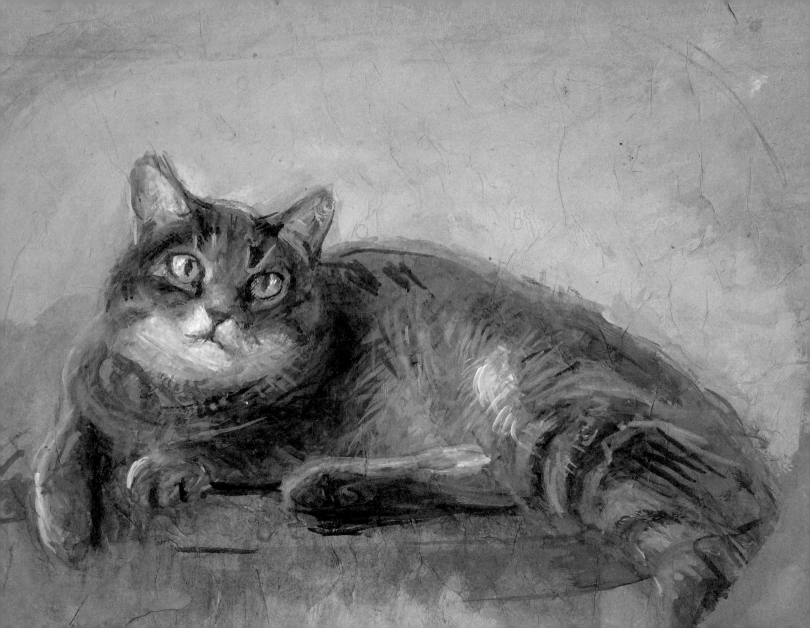

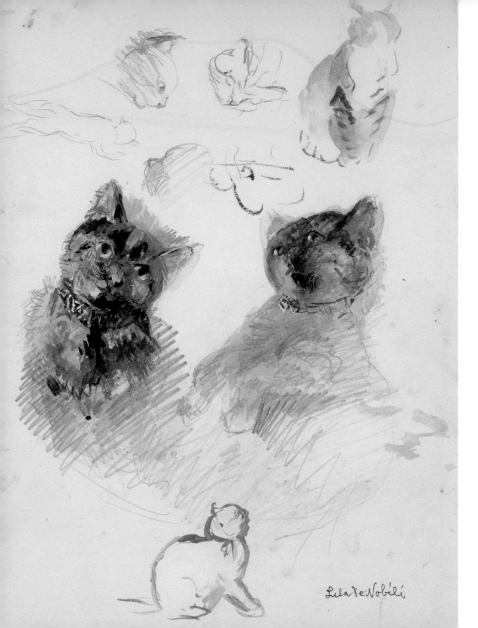

Two portraits
of Aphrosine;
sketches of cats

Three studies of a small bunch of roses from the garden; portrait of Grisou sleeping

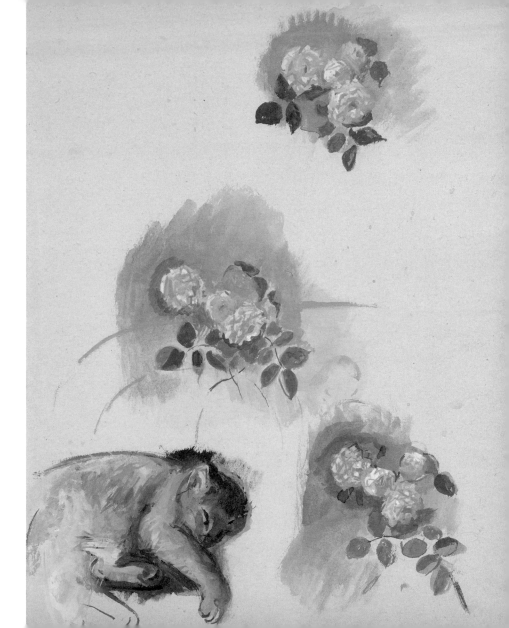

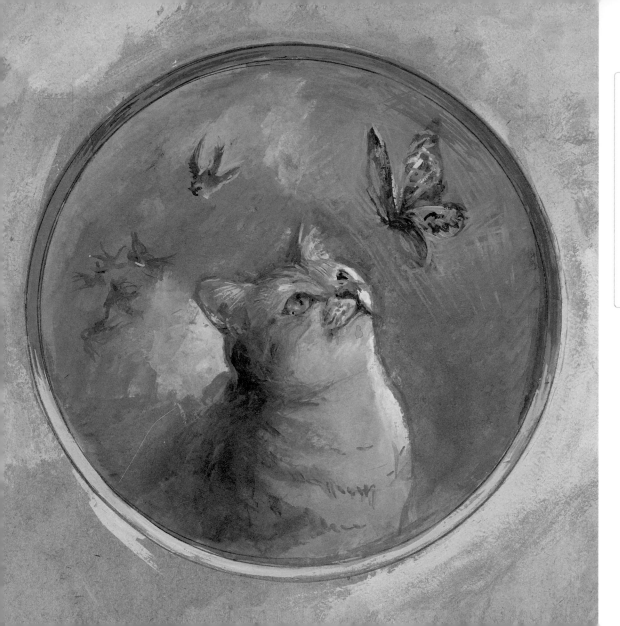

This and the following pages:
portraits of Plick and Plock,
the kittens of a Persian Chinchilla
and one of Levallois's tabby cats,
beloved companions of Lila's
friend and veterinarian, Jacqueline
Peker. Also see p. 67
On the left: portrait of Plick,
an aloof but extremely observant
cat, looking at butterflies.
On the right: portrait of Plock,
the male, an extremely
affectionate, sometimes bossy
kitty, lover of music
and the countryside.

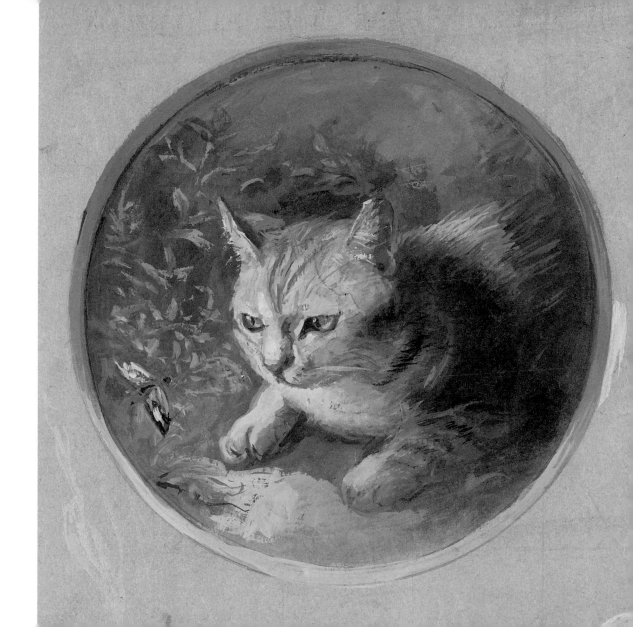

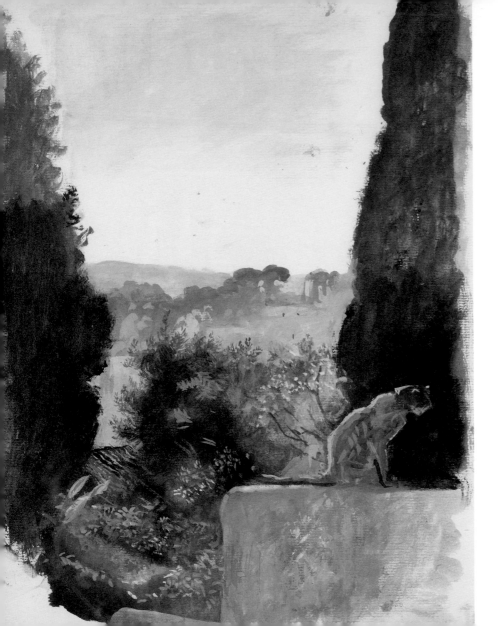

Grisou in profile
on the edge of a terrace
in Aubagne

Opposite page: Grisette,
born of Ulysses and a tabby cat,
in the entrance of a house
in Aubagne

On the following page: the cat Lila
Malatesta at her house in Milan

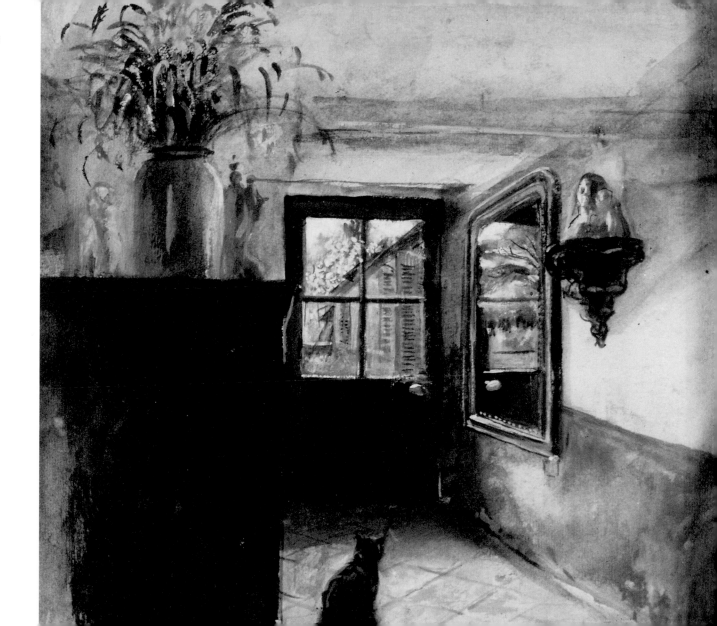

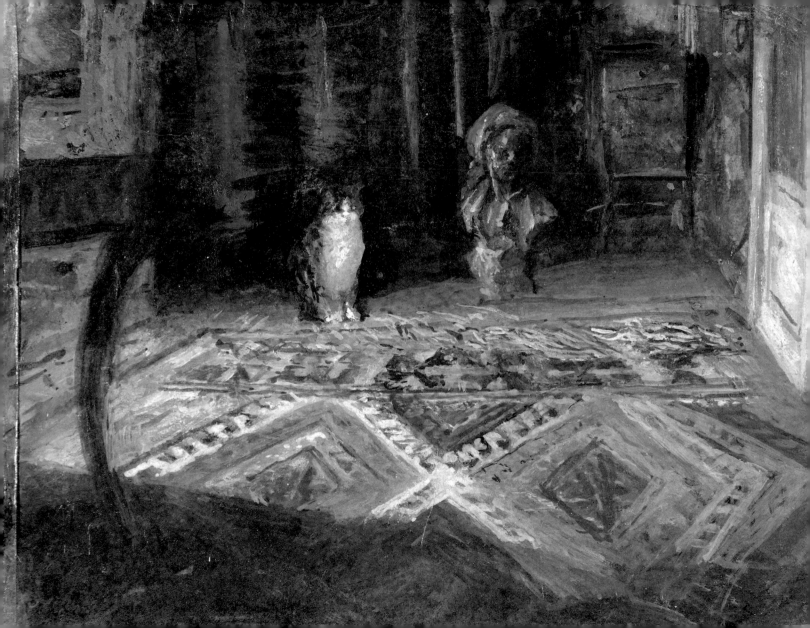

fantasies and stories

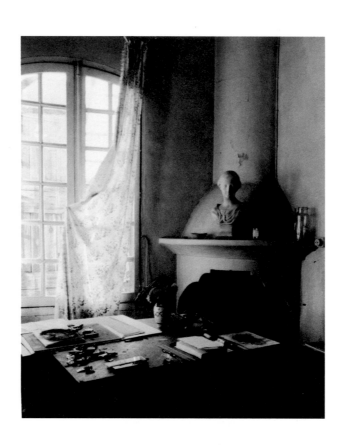

'All the world's a stage, And all the men and women merely players; They have their exits and their entrances, And one man in his time plays many parts.'[1] Shakespeare transports us through his work into a world in constant change, where the characters are in a perpetual state of development: changes in sex, disguises, powerful people who lose their power or get it back, people who turn into animals. Working for the theatre, Lila encountered this wondrous world on multiple occasions, transforming Bottom into a donkey in Shakespeare's magical *A Midsummer Night's Dream*,[2] and, later, creating the shrimp-women in *Le roi des gourmets*,[3] and for the visions in *Mario e il Mago*.[4]

When representing an animal, the most important thing is to transform the face of the actor or dancer. Most of the time, the costume designer settles for more or less accurate make-up, a mask with a few feathers for a bird or a velvet mask with little ears and whiskers for a cat.

One of the last productions that Lila worked on, the ballet *The Sleeping Beauty*,[5] offered an opportunity to work in this vein. In the first act, for the baptism of Princess Aurora, Lila included some evil creatures—toads and rats—in the Carabosse fairy's entrance and, the third act, during the *pas de caractère* of the wedding, various characters from fairy tales, such as Puss in Boots and the White Cat. Her collaborator Rostislav Doboujinsky created extremely light masks for all of these characters.

In *Heartaches of an English Cat*,[6] Balzac levelled a ferocious attack on the society of the age under the pretence of telling the story of a white cat named Beauty. Cats had been a part of Lila's life from a young age, and she could not help but love that adorable cat with literary ambitions who declares, on the very first page: 'I have so many proofs of the superiority of Beasts over Man.' Although Lila was no longer working in the theatre world, she was the one to suggest creating a play out of it, and the production debuted in 1977,[7] with Rostislav Doboujinsky, by then a specialist in this type of work, creating complete animal heads for each actor.

In her everyday life with cats, Lila could hardly limit herself to taking them in and caring for them, drawing on her literary background to imagine them as characters in fantastical stories and films. The letter from the exiled Siamese Prince and the gouache of a Siamese ballet, reproduced here side by side, were for two different friends, but were from the same period and have the same subject. The adventures of the tiger-striped cat Nana, the name of

her first cat and later that of her friend Jean-Marie Simon's beautiful tabby,[8] could have been the subject of a movie or comic strip.

Lila often created cards or letters accompanied by drawings or gouaches as thanks and for special occasions like birthdays and births. For her, it was a way of staying in touch with the people dear to her, and each work was conceived in relation to the interests and life events of the recipient. For her friend Umberto, founder of the the maison of theatrical costumes «Sartoria Tirelli», she created a drawing of cats dressed in the black and white clothing of Pierrot, for its similarity to the coat of his Dalmatian. Whereas for the birth of the first child of a friend who had admired a small wax Madonna in a church, all dressed in lace, as a girl, she reproduced that work in tempera amidst white flowers and framed by cats and baby bottles.

In the spirit of the earliest projectors, Lila was inspired by the method used for magic lanterns, overlapping two images: in the gouache reproduced here, we see two girls hidden by *Le journal des Grisettes*, but then, in transparency, they become two young cats laughing hysterically.

Lila observed the world with an amused and ironic eye: in her thank you letter for the gift of a basket, she first wrote in her own name in lovely script, then continued with a few scrawled lines of complaint from the cats, who claimed ownership of the basket.

Other times, she felt compelled to comment on some especially amusing thing that she had seen, for example her drawing of the cat Alice, who helped Mitzi give birth, depicting the former as a Red Cross nurse.

Lila loved to surround herself with children, and children loved to spend time with her.

She knew how to capture their attention, inventing funny stories, and as soon as they were capable of holding a pencil in their hands she encouraged them to draw. Although she did not want to call these drawing sessions 'lessons,' she taught them the basics and guided them according to their aptitudes, some towards perspective drawing, others towards painting on porcelain, and she also drew examples for them to copy, including cat subjects.[9]

When her home-studio became filled with cats, it was therefore entirely natural for Lila to make them into the leading characters of imaginative stories and drawings of her own invention, an exercise that was already familiar and brought out the child in her, while creating dialogue with the children around her.

Sketch of costumes for the White Cat, Puss in Boots, Little Red Riding Hood and the Wolf for the 3rd act of the ballet *The Sleeping Beauty*, Covent Garden, London, 1968

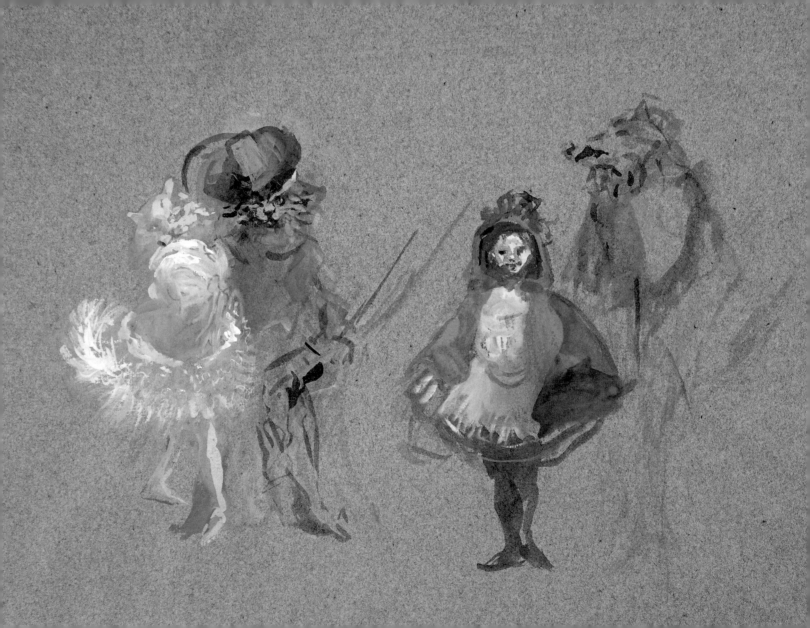

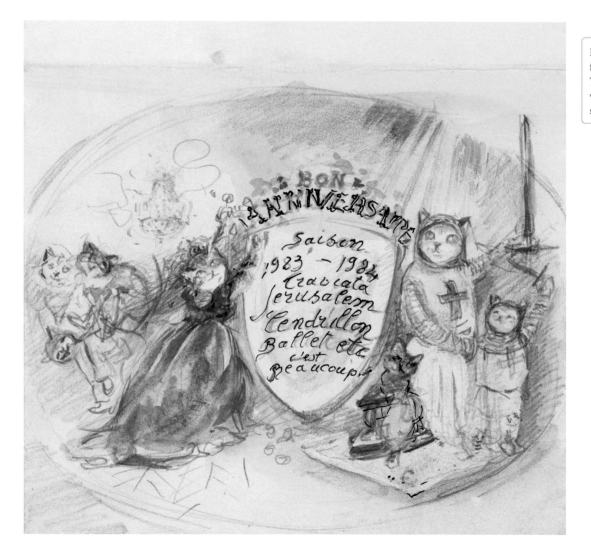

Birthday card
for a costume designer
The works cited in the text
were from the 1983-1984
season

Les Nuits musicales d'Aubagne
Illustrated letter addressed to friends
with a house in Aubagne.
Grisette, a kitten fathered by Ulysses,
was their cat.
The Fellini film referred to in the letter
is the *Orchestra Rehearsal*, which came
out in 1979.

Dear Michel, Claudie, Emmanuelle, Coralie and Grisette,
This is an idea for 'Evenings of Music' that Grisette is dreaming
of doing. First, she sings accompanied by fat toads and a
cricket organist. Then, at the end, she eats the orchestra.
She has been hearing a lot about Fellini's film (plus she is
a little bit of a megalomaniac like her father Ulysses)

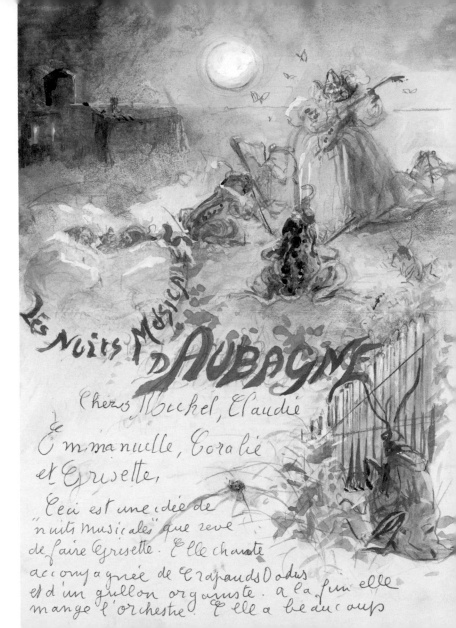

Temporary seat
of the exiled Siamese government
16, rue de Verneuil Paris

Forgive the use of this letterhead
from my time
in the House of Lords
But it is the only decent and unstained
sheet that I can find

My dear friend (as a fellow artist, I hope you don't mind my addressing you thus),

Please forgive my delayed reply to your lovely and fascinating letter, but when it comes to serious correspondence, I want to be able to concentrate properly on my reply, and it is so difficult to do in this house!!!

First and foremost, please be advised that the content of this letter has not been shared with our landlady, who saw to sending it to you. It was a difficult decision to withhold our trust from this poor woman, although she and the modest lodging that she has provided to us leave much to be desired. But never mind…

The fact is that I have not read the book in question, since I am utterly allergic to any attempt to analyse my behaviour, as this would be potentially damaging to my dignity as well as depressing or at the very least upsetting.

But that is not why I am writing to you now. My secretary, the young Marc-Michel, has told me that he met you at the Théâtre Français.

I would like to show you the polyphonic Siamese ensemble that myself, my wife and my children have created. (Regarding the little ones, we will have to wait for the next litter, as this one, due to an inexplicable error, is imperfect in terms of hue and would not be able to wear the golden costume of our beloved national tradition, so derided by the recent events in Vietnam).

We have an assistant, a good, solid kid, however of common stock, named Rouki (an orphan who was nursed by my wife, Rodecka) who would be a great help on tour, for transporting the organ, etc.

I am sorry that I am as yet unable to send you a pressbook (our landlady has tried to put one together, with the help of some (Greek!) photographers, but good intentions are not enough and she is completely inadequate).

She said that she would prepare some "presentation sketches" for us.

Just between us, I have no faith in her, but she must be encouraged anyway: in our situation as exiled princes all good intentions need to be benevolently accepted. And indeed, we have no other choice.

Please accept my deepest admiration and hopes for your speedy recovery and happiness for your family, especially your daughter Emmanuelle, who in her mimickery achieves an almost Siamese grace in her poses (what a waste! But alas, we are charitable).

Yours truly,
Prince Ulysses Nyuisen Hi

Draft for a fantasy ballet with Siamese cats.
During the same period, in December 1976, Lila wrote a letter to a musician friend in the guise of Ulysses, a Siamese cat and exiled prince.

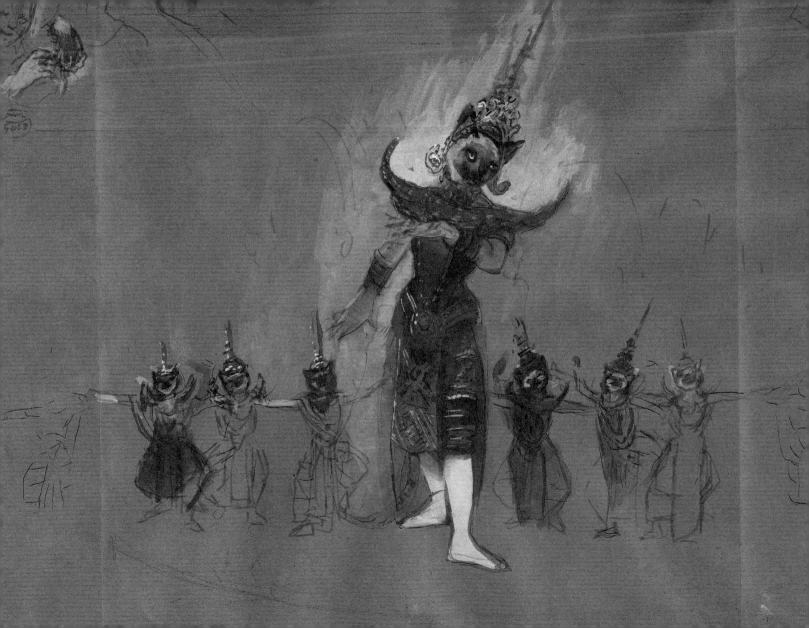

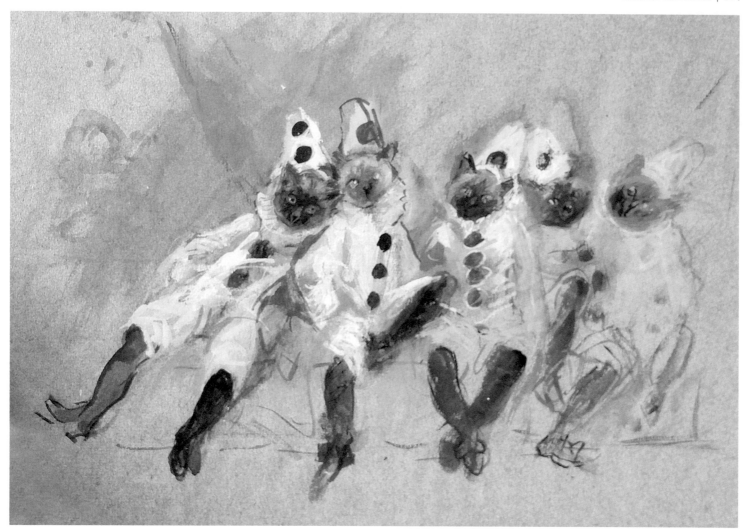

Opposite page: Siamese cats
dressed as Pierrot
The composition of the gouache
is inspired by the *Kinderkarneval*
(1888) by German painter
Friederich August von Kaulbach,
which depicts Katia Pringsheim,
the future wife of Thomas Mann,
and her brothers

Cat dressed as a can-can dancer

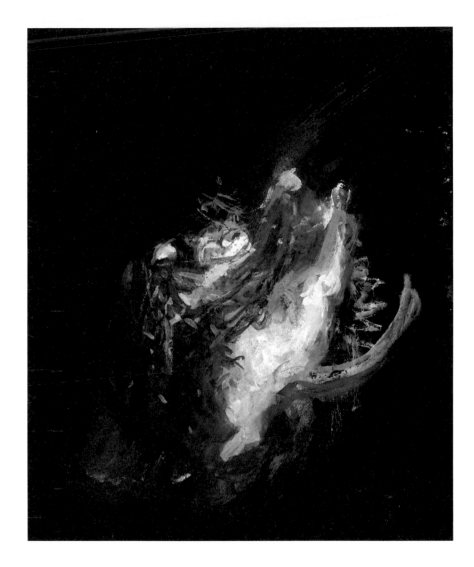

The first part is written in Lila's voice: *We would like to thank the screen-printing department for its artistic contribution to the marvellous Christmas basket and its thoughtfulness in also including pockets for the next litter.*

But the second part comprises a few lines of complaint from the cats: *Indignation constrains us to inform you that, as soon as we came into possession of the basket, it was removed and placed outside of our reach, even though it was clearly meant for us. It is apparently needed for a trip during the Christmas holidays that we will not be party to. We just wanted you to know, although it in no way diminishes our gratitude.*

Rouki, Union Representative
(cc. Grisou, Accountant)

Opposite page: gouache given
in thanks for a basket brought back
from Turkey. The 'odalisque' cat is
Valentine, the offspring
of Rouki and Mitzi

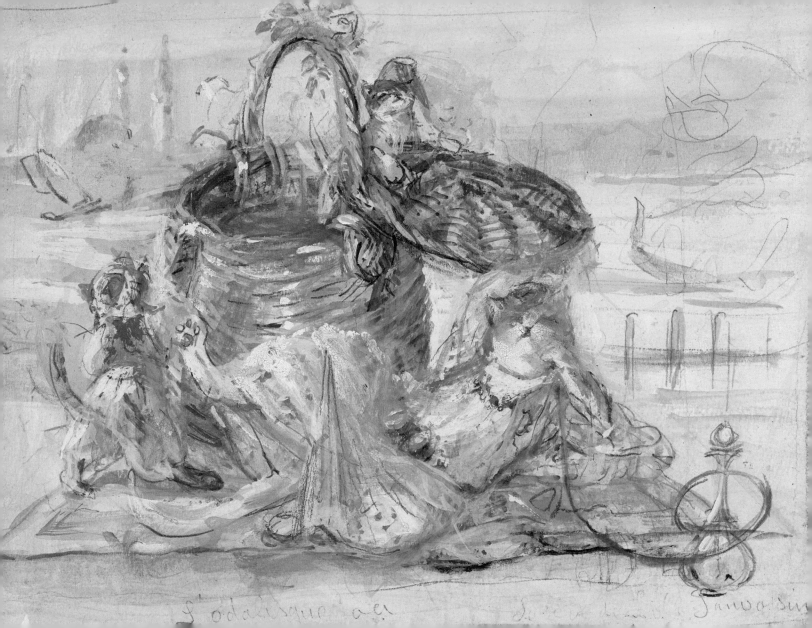

L'odalisque a... Janvoi...

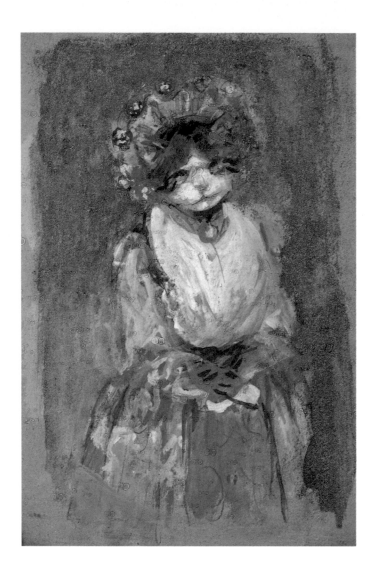

The cat Lila Malatesta
dressed as Lucia Mondella,
the heroine of Manzoni's novel
The Betrothed

Opposite page:
two cupids framing a small cat.
Overdoor for a house in Milan

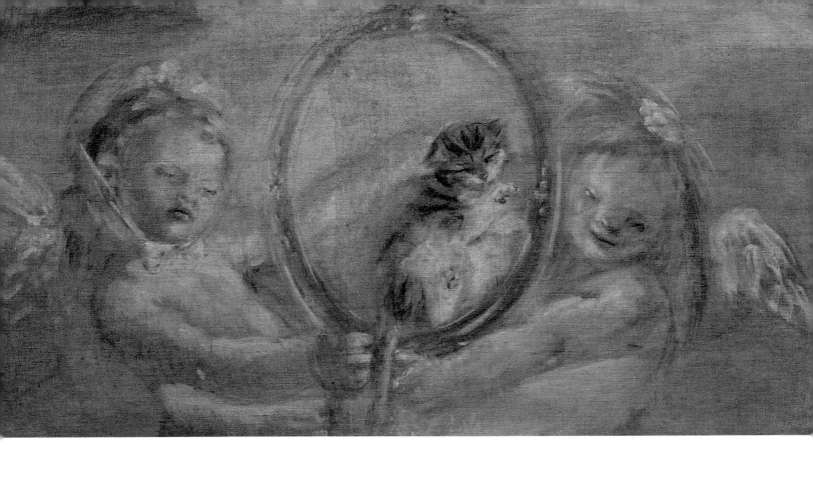

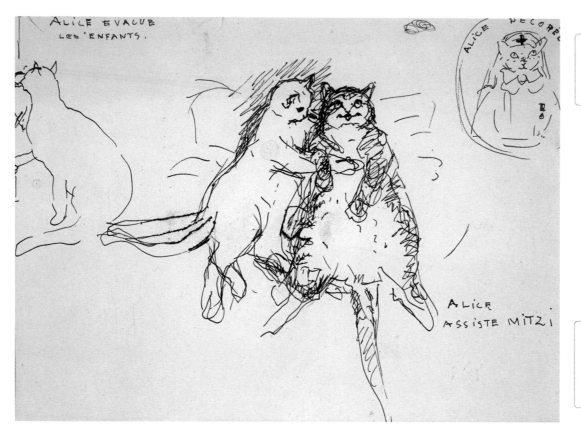

ALICE EVACUE LES 'ENFANTS.

ALICE ASSISTE MITZI

Alice the obstetrician.
Card commemorating the cat
Alice's assistance to Mitzi while
the latter was giving birth

Opposite page:
Mary as a child framed by cats,
baby bottles, and flowers. This was
a congratulations card for the birth
of a friend's baby

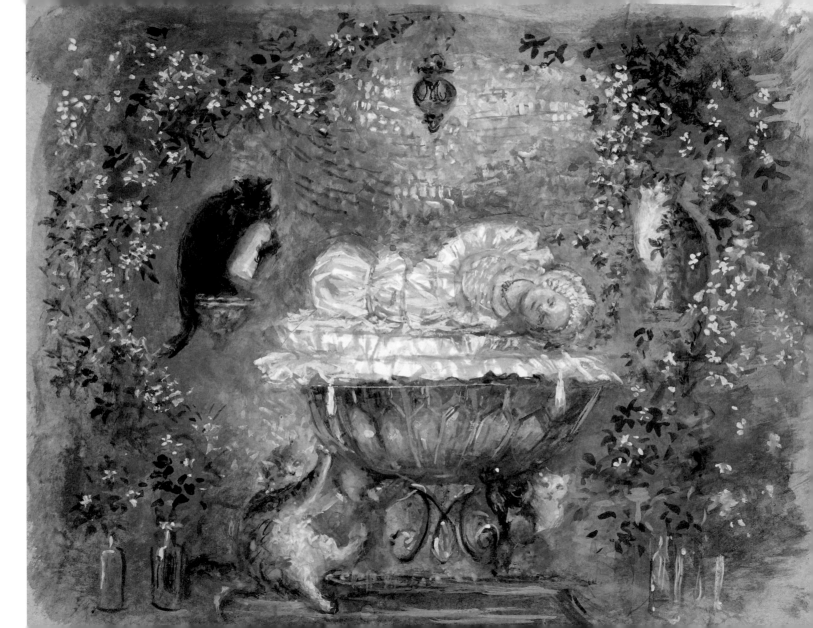

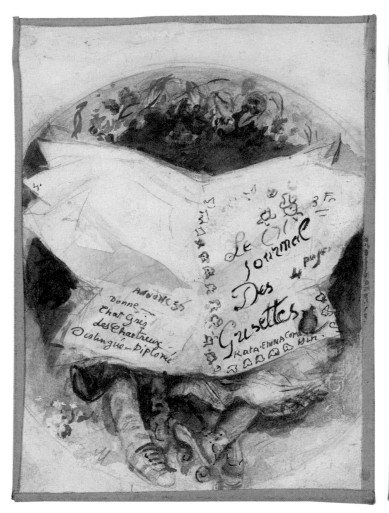

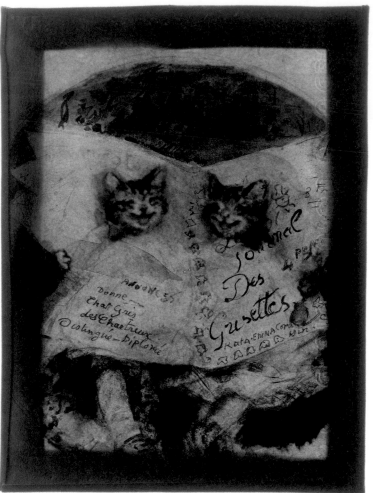

Opposite page:
Le journal des Grisettes.
Here, the occasion was the 'home-made' comic produced by a small group of school friends.
Lila dedicated these two overlapping sheets to them, depicting two girls reading who in transparency become two young cats laughing.

'*Together*': an affectionate card featuring Mitzi and Rouki

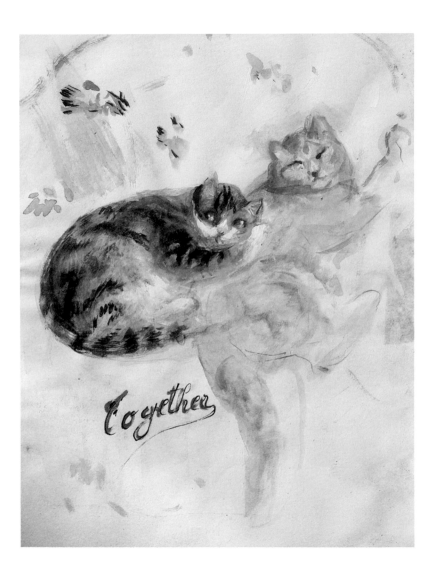

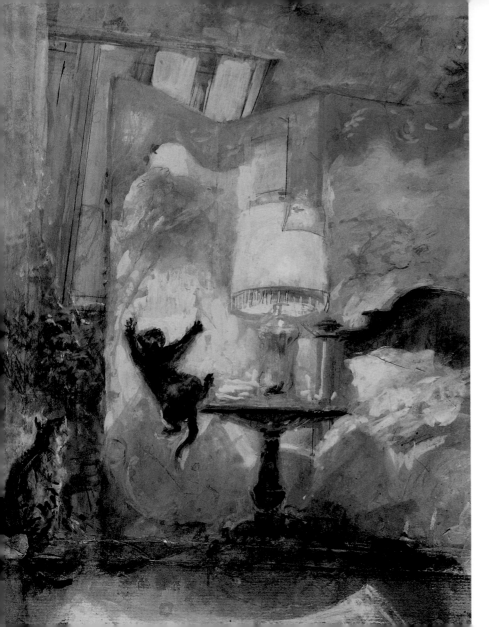

The bedroom of Lila's friend
Jean-Marie with the cat Oscar
climbing the screen, and another
cat observing

Opposite page:
fantasy featuring Mitzi,
little girl-butterflies and costumes

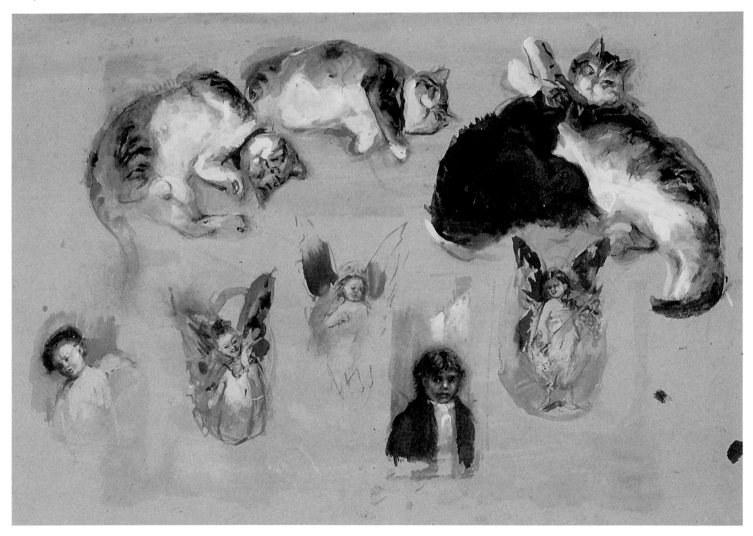

Fan with Christmas greetings,
featuring Mitzi, Ulysses, Rodecka
and Rouki

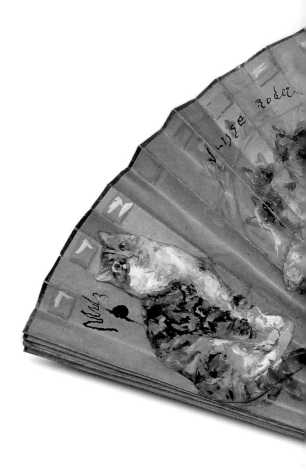

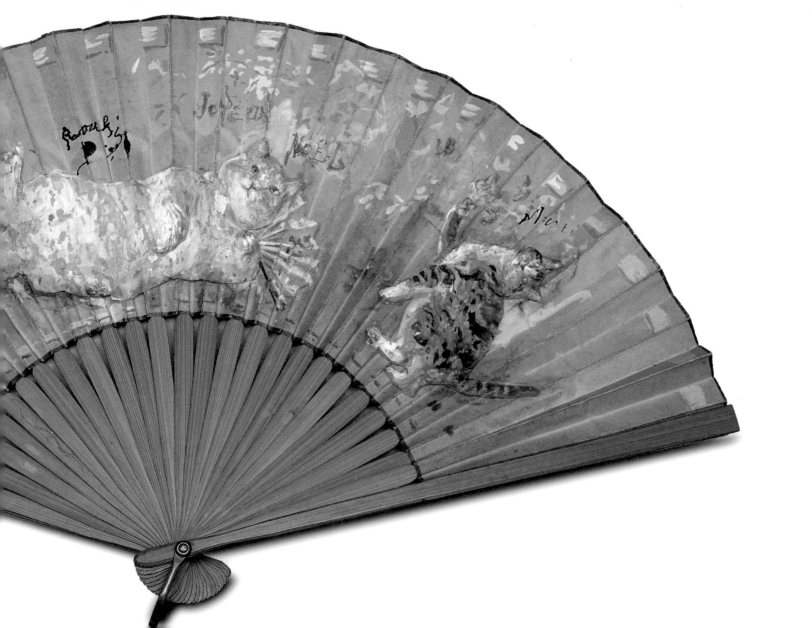

Fan, featuring Mitzi
in various poses
with pink ribbons

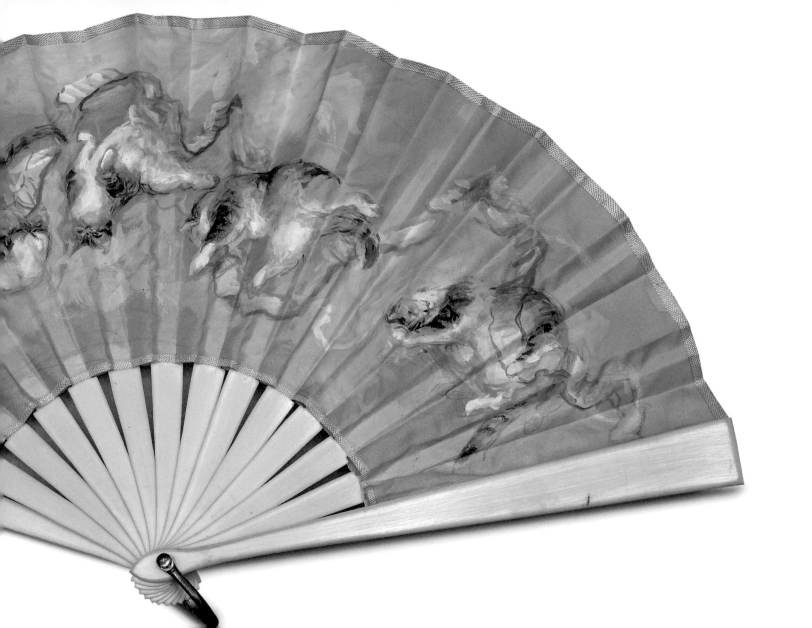

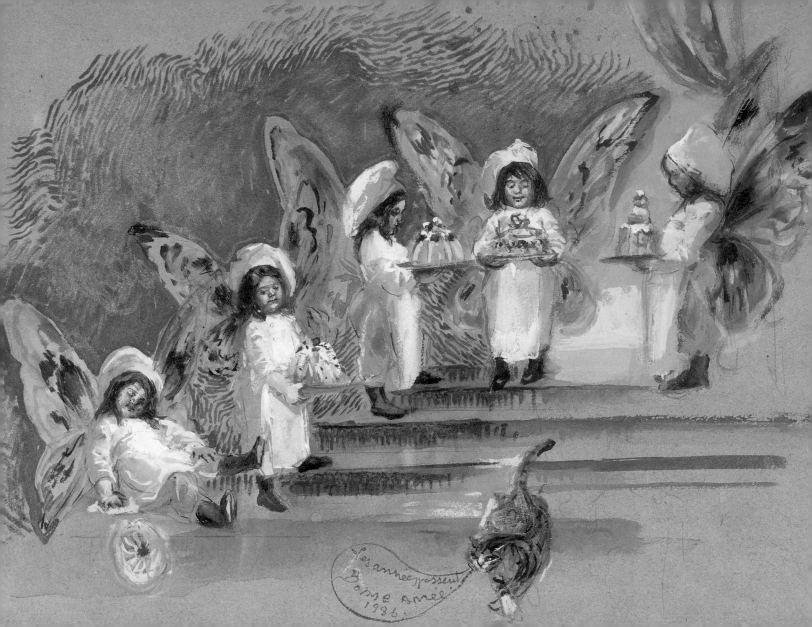

Opposite page: Grisette the tabby
cat offers 1986 New Year's wishes
to her young owner, who is
represented at various ages
in the pastry chef costume
she wore as a young girl
to a Carnival celebration

Young cook, goose and cat
Sketch for a tea towel

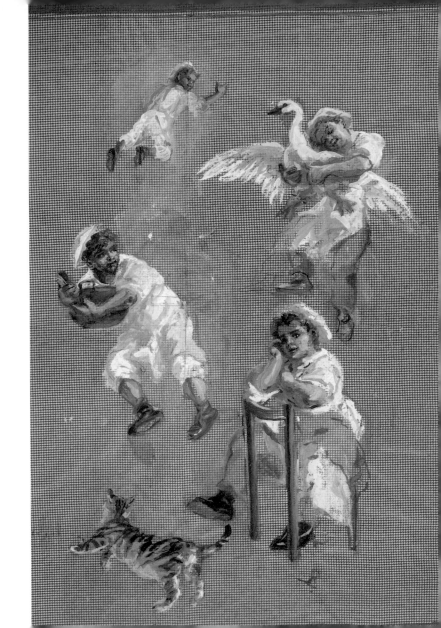

Pavlos and Marc-Michel
These images are from an illustrated story in which cats play the part of two of Lila's neighbours, who also sometimes modelled for her.

P. 133
Pavlos (temporary name)
an English cat, a kind of Billy Liar
He had a car, but sold it
to gamble. Loses every thing, tries
all kind of grand, hopeless schemes
Dresses like Puss in Boots, minus
the boots.

Marc Michel, a French cat
very sententious and condescending. Tries
a lot of jobs: baby sitter, decorator.
He loses them all because of his
superior attitude. He wears a red
Phrygian cap. He used to have
a guitar, which he has sold.

P. 134
Nana: a tabby – distressed
gentlefolk type. She wears a beret
an old silver fox, ragged stockings
and thermoshoes. She carries a lot
of bags and parcels. She is
completely absent-minded, vague
and hopeless, as well as rather proud
She has been helped by distressed
gentlefolk association, but drinks
and has been known to behave
very badly.

Little Suzan: white, pretty
angora. She can sing, but eventually
falls asleep everywhere all
the time.
She wears a baby doll dress
or a choirboy supplice with
long black boots.

P. 135
Nana has a job as a cleaner
(Nana and her children clearing)
Her children cause havoc
(Nana's children destroying the living room)
(Nana and children fired)
Nana loses her job
(Nana fired from her cleaning job)

P. 136
THE END

On the following pages:
first version of Nana, Little Suzan, second version of Nana.
Fantastical illustrated story.

Pavlos. (temporary name)
~ English cat. a kind of Billy-Liar
~ has had a car, but sold it
~ gamble ~ Loses every thing, too
~ kind of grand, hopeless scheme
~ ress like Puss in Boots minus
~ he boots ~

Marc Michel ~ A French cat
Very sententious and condescending ~ Tries
a lot of jobs = baby sits, decorator ~
He loses them all because of his
superior attitude ~ He wears a red
phrygian cap. He used to have a
guitar, which he has sold.

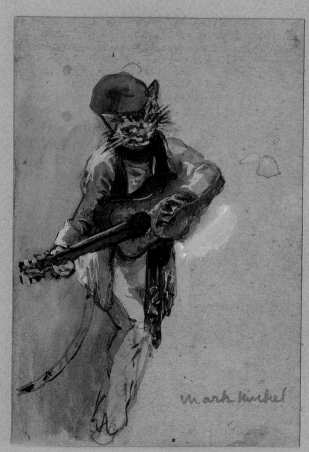

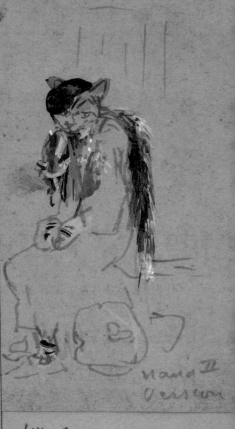
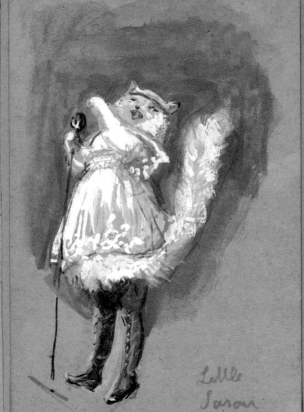

Nana: a tabby - distressed
gentlefolk type - She wears a beret
an old silver fox, ragged stockings
and tennis shoes - She carries a lot
of bags and parcels. She is
completely absent-minded, vague
and hopeless, as well as rather grand
She has been helped by distressed
gentlefolk association — but thinks

Nana
version

and has been known to behave
very badly

Little
Susan

Nana II
Version

Little Susan — white, pretty
anyone She can sing but unfortu-
falls asleep everywhere all
the time.
She wears a baby doll dress
of a choir boy surplice with
long black boots

Nana has a job as a cleaner

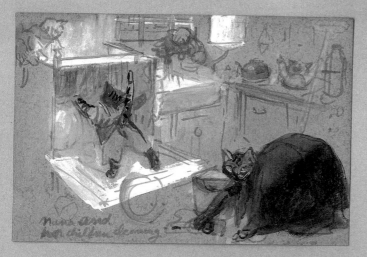

Nana and her children cleaning

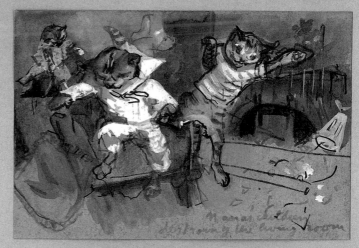

Nana's children destroy of the living room

her children cause havoc

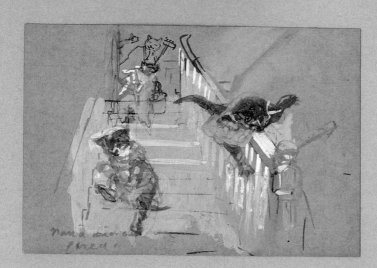

Nana divorced fired.

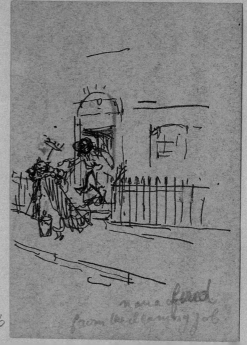

Nana fired from her cleaning job.

Nana loses her job

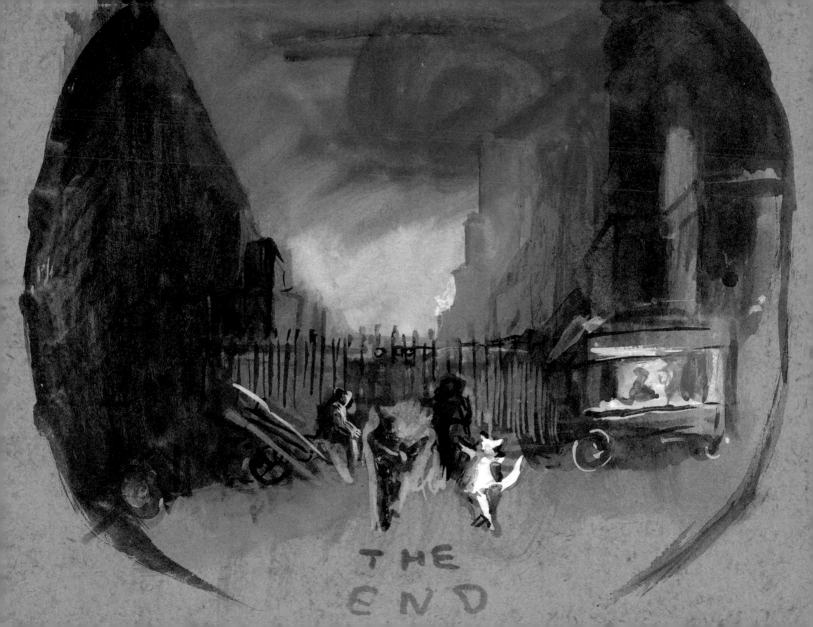

Dominique

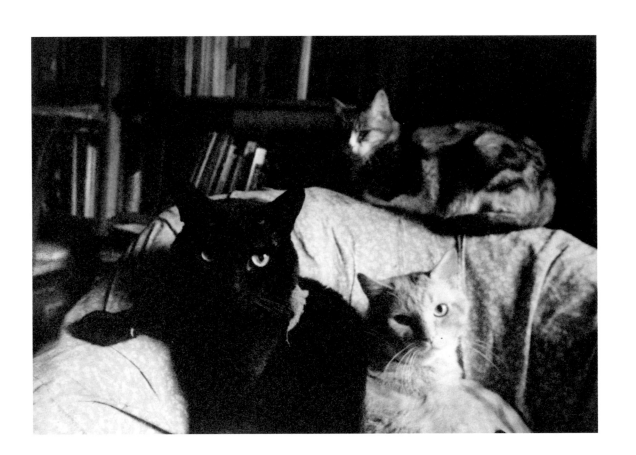

A Story by Lila De Nobili

Dominique was born in a litter with Pasha and Kim, and was supposed to be given away, but Kim, a bright, memorable kitten, was chosen instead. Dominique was a bit of a runt and he took his name from 'Dominique negra,' a girl who used to visit me, full of good intentions, took it upon herself to feed, and then overfeed, him, to the point of nearly suffocating him one day with a piece of cheese. And so she became his godmother. One day when he seemed to be truly sick, I brought him to the veterinarian. I don't know what kind of shots they gave him, but the young nurse who came to tell me that he was 'très bien' laughed while she said it, since this miserable little puff of black fur had fully regained his will to live and then some.

Dominique's mother was Rodecka, a sweet and modest saintly Siamese mama cat, and his father was a diabolical tom who seemed to have tumbled off of some scaffolding, still a chaton, and was then brought to me by the vagabond Dominique. He was called Rosemary's Baby, the 'Devil's Child.' He was crooked and tiny, with no tail, a little black monster, but he had a beautiful face, full of courage and passion. He fell from the window again, but he didn't die, and I brought him hope against hope to the big veterinary hospital in Maisons-Alfort. They operated on him for lasted hours and hours, while I paced the streets of Maisons-Alfort sick with worry. He survived and was put in a long cast, and his poor little skeleton healed. Time passed, and the cast was removed. Rosemary's Baby came out hairless but full of energy. There were no other male cats in the house at the time, because Ulysses was travelling with Marc-Michel. Rosemary's Baby became a Don Juan. He was very confident, his fur grew back and his face sparkled with intelligence, he was strong like the dwarves in fairy tales. And so Pasha, Dominique and Kim were born. Rosemary's Baby, wearing a pretty amber necklace, was given to a Surrealist library.

Dominique joined the clan of Mimì's descendants: Rouki, Mitzi and the white cats. His glossy black coat looked wonderful amidst their cream-like colours. He was very attached to his mother Rodecka and watched over her until the end, when she was sick with asthma and emphysema.

When Grisou came to live with us, everything got worse. The clan became self-aware and hostile to the intruder. Grisou was a tabby and would have been gorgeous, but he had had 'des malheurs'. One of his ears was shrivelled into nothing. His age was unknown, but he must have been quite old. He was castrated and this was probably done late in his life, since he had a virile, austere, dignified personality and no fear of a fight. The cat family spared him no slight. Especially Dominique, who liked to provoke him. Like all Siamese, he

was a talker and, when the tins of food were opened at mealtime, they threatened each other, telling each other off, nose to nose, like in a gangster film. And then, when there were kittens, Dominique set himself to protecting them from imaginary dangers, since Grisou loved the chatons and, when he could, cuddled them in secret. Dominique, in order to look good in the eyes of Mitzi, to whom he was uncle, devoted servant and sometime-husband, threatened Grisou in silence, tail twisted one way, head the other, vilifying him as if he were an ogre, paedophile or kidnapper.But it soon became clear that this was all just staged, parts and roles to be played. Indeed, sometimes it seems as if Dominique was limping terribly, other times not. The veterinarian couldn't find anything wrong and thought that he simply had a neuro-arthritic temperament. Out of all of these cats, he was the only one possessed by a kind of passion or rage, but he was also the only one to suffer. From what? Maybe from not having a female cat of his own, said Jessica. Or maybe it was his strange body, bulky, heavy, strong, but lacking agility. A Chinese bronze.

He was beat up often, but not by Grisou, by Rouki. He had sores from the bites, always in the same place. They didn't heal, and he had various protective 'costumes.' Once, the veterinarian wrapped him up neck to tail, he looked like a masquerader, a Pierrot. Another time, he had a vest that gathered at the neck, like a ruff. Then a quilted black doublet kept closed with a silver pin in the shape of a cat's head was made for him. In his mind this costume suited him. When the weather got hot and I took it off, I found a terrible infection underneath. I washed it carefully and put a black nylon sock in its place, which had a gilded foil half-moon stuck to it for a while, hanging from a bright pink piece of thread.

Now that he is gone, I would like to talk about the best moments in Dominique's life, moments of intense solitude. Summer afternoons, when the whole cat family was snoozing on the armchair, all of the hues of the sunrise mixed together, Dominique settled on the arm, almost standing, looking into the tiny room as if at a distant horizon. What was he thinking about? Perhaps one of those moments of mournful clairvoyance that we all have from time to time, or memories of a happy kittenhood, his mother Rodecka. I thought he was sleeping but then, seeing him from the front, his gorgeous emerald eyes were open, looking into the distance like a myopic's, his big head resting on his short, crooked paws, crossed in front of him. Or on winter evenings at dusk, seated on the cupboard, he would watch nightfall and everything became full of meaning. From beyond the walls of the house next door we could hear the city. And it wasn't the Paris of today, but the one of Steinlen.Other times, stretched out on his back in the sun, with his half-moon hanging from his neck, he played with a bit of paper or a peel, making it jump around with his short, sturdy legs, and it reminded me of the scene in *Petruska* when the Moor is resting in his room, lying down, and playing with a ball with his feet, and just like him, Dominique laughed…

It's all finished now. I will never see again his small, short and pensive silhouette, I will never let him sleep – exceptionally – on my bed, giving way to an outburst of joy… He only wanted lots of love , and he did not have it. Why didn't I do it more often? It was so easy!

Paris, July 1988

Notes

Biography

1. Marcel Vertès (1895-1961), painter, illustrator, set designer and contributor to *Vogue*. He lived in Vienna, Paris and New York. In 1952, he won an Oscar for his sets and costumes for John Huston's *Moulin Rouge*.
2. Letter to Emmanuelle Sanvoisin at the end of 2001.
3. From Lila De Nobili's notebook *Apprentissage à l'envers*, written in 1998-1999.
4. Ibid.
5. Renzo Mongiardino (1916-1998), architect and e set designer.
6. Ibid.
7. In France, in November 1942 the *Zone libre* of Vichy regime was invaded. Following a pact between Hitler and Mussolini, Italian troops occupied the border area between the Maritime Alps and Haute-Savoie. Villa Nobili is requisitioned and becomes initially the seat of the OVRA, the fascist political police, and after Mussolini's destitution in 1943, one of the offices of the Gestapo.
8. Ibid.
9. *Rue des anges*, play in three acts by Patrick Hamilton, directed by Raymond Rouleau, Théâtre de Paris, Paris, 1947.
10. Piero Tosi (1927), costume designer and set designer, teacher at the Centro Sperimentale di Cinematografia in Rome.
11. Yannis Tsarouchis (1910-1989), painter and set designer.
12. Christine Edzard (1945), director, screenwriter, set designer, founder, with Richard Goodwin, of Sand Films in London.
13. Emilio Carcano (1939), collaborator and friend of Renzo Mongiardino and Lila, painter, set designer and interior designer.
14. Gioia Fiorella Mariani (1934), set designer, costume designer, director of movies and documentaries.

Rue de Verneuil

1. Letters to Renzo Mongiardino, 18 December 1945 and 21 March 1946.
2. Letter to Renzo Mongiardino, 29 October 1946.
3. From 'Le chat,' in *Le Bestiaire, ou Cortège d'Orphée*, 1911: 'un chat passant parmi les livres.'
4. Letter to Renzo Mongiardino, 10 August 1981.
5. Undated letter, but from the early 1980s, to Claudie Gastine.
6. From the letter from Stéphane Mallarmé to Théodore Aubanel dated October 1864.

Studies and Sketches

1. Letter written in 1983 to Claudie Gastine.
2. Letter to Francesca Simone, 8 April 1998.
3. Letter to Fiorella Mariani, 1980.
4. Ibid.
5. Letter to Francesca Simone, 3 ottobre 1987.
6. Undated letter, but from the early 1980s, to Claudie Gastine.
7. Undated letter, but from the early 1980s, to Claudie Gastine. The term *grisettes*, with which Lila referred to three young grey cats, was used in Paris starting

in the nineteenth century as a nickname for workers and dressmakers, whose garments were commonly made of a sturdy grey material. Elegant in spite of their limited economic means, the grisettes often lived in mansard apartments and were part of the Bohemian milieu as artists' lovers and models. There are two statues dedicated to them in Paris, and they also figure in numerous novels and plays, including Gustave Charpentier's *Louise*.

Portraits

1. Letter from Renzo Mongiardino to his mother Laura, 13 August 1926.
2. Letter to Salvatore Russo, September 2000.
3. Letter dated 23 April 2000.
4. Letter to Umberto Tirelli, undated.
5. Letter to Francesca Simone, 25 July 1988.
6. Letter to Renzo Mongiardino, July 1988.
7. Letter to Francesca Simone, 20 September 1991. Jessica was the child who lived in the apartment next to Lila's.
8. Letter to Francesca Simone, 22 November 1997.

Fantasies and Stories

1. *As You Like It*, William Shakespeare, Act II, Scene 7.
2. *A Midsummer Night's Dream*, William Shakespeare, directed by Peter Hall, Shakespeare Memorial Theatre, Stratford-upon-Avon, 1959. The role of Bottom was played by Charles Laughton.
3. *Le roi des gourmets*, choreographed entertainment by Giulio Cesare Breno, themes from the *Suite gastronomica* by Gioachino Rossini, directed by Raymond Rouleau, choreography by Jean Babilée, Teatro dell'Opera, Rome, 1964.
4. *Mario e il Mago*, from the story by Thomas Mann, directed by Luchino Visconti, music by Franco Mannino, Teatro alla Scala, Milan, 1956.
5. *The Sleeping Beauty*, music by Pyotr Ilyich Tchaikovsky, choreography by

Marius Petipa with new choreographic additions by Frederick Ashton, sets by Henry Bardon, costumes by Lila de Nobili and Rostislav Doboujinsky, Royal Opera House, Covent Garden, London, 1968.
6. *Peines de cœur d'une Chatte anglaise*, story by Honoré de Balzac with illustrations by Grandville in *Scènes de la vie privée et publique des animaux*, Hetzel, 1841.
7. *Peines de cœur d'une Chatte anglaise*, play by Geneviève Serreau based on the story by Balzac, directed by Alfredo Arias, sets by Emilio Carcano, costumes by Claudie Gastine, masks by Rostislav Doboujinsky, music by Michel Sanvoisin, Théâtre Gérard Philipe, Paris, 1977.
8. Jean-Marie Simon (1936-1991), set designer, costume designer, director of movies.
9. As an example of Lila's teaching method for children, see the image on the next page.

① ② ②

sur le oiseau perpendiculairement
e regard (parallèle au visage, incliné vers
haut ① vers le bas ② vers le ② droit.

②

Comment se servir de l'appareil

Croque – Grisette. (Breveté)

❈ – Croque – Grisette – modèle déposé
3 Rue du Foin TV°

Bibliography

Felice Cappa, Piero Gelli, s.v. "Lila De Nobili". In *Dizionario dello spettacolo del '900*, edited by Felice Cappa, Piero Gelli. Milan: Baldini & Castoldi, 1998.

Niki Grypari, Fani-Maria Tsigakou, Maria Diamandi (eds.). *Lila De Nobili – Yannis Tsarouchis: An Encounter*. Exhibition catalogue (Athens, Benaki Museum, July 4 – September 23, 2002). Athens: Benaki Museum – Yannis Tsarouchis Foundation, 2002.

Vittoria Crespi Morbio. *Lila De Nobili alla Scala*. Milan: Edizioni del Teatro alla Scala, 2002.

Gianni De Nobili. *Viaggio a Vezzano*. In Anna Rozzi Mazza (ed.). *Lila De Nobili. Una spezzina alla Scala*. Exhibition catalogue (La Spezia, Palazzina delle Arti, February 8 – 4 May, 2003). La Spezia: Stampa litografica Europa, 2003, 13-15.

Alvar González-Palacios. *Itinerario di Lila. In Damiani, De Nobili, Tosi. Scene e costumi. Tre grandi artisti del XX secolo*. Exhibition catalogue (Rome, Accademia di Francia, Villa Medici, January 27 – April 2, 2006). Milan: Skira, 2005, 21-40.

Dino Trappetti. *Due artisti, due mondi, un mondo. In Damiani, De Nobili, Tosi. Scene e costumi. Tre grandi artisti del XX secolo*. Exhibition catalogue (Rome, Accademia di Francia, Villa Medici, January 27 – Aprile 2, 2006). Milan: Skira, 65-66.

Alberto Scaramuccia. *Spezia 1908. Prospero De Nobili e il problema Tribunale*. La Spezia: Edizioni Cinque Terre, 2009.

Vittoria Crespi Morbio. *Lila De Nobili. Theatre Dance Cinema*. Parma: Amici della Scala / Grafiche Step Editrice, 2014.

Vittoria Crespi Morbio. *Atmosfera: Lila De Nobili. In Incantesimi. I costumi del Teatro alla Scala dagli anni Trenta a oggi*. Exhibition catalogue (Milan, Palazzo Reale, October 10, 2017 – February 4 2018). Parma: Amici della Scala Scala / Grafiche Step Editrice, 2017, 30-32.

Pier Gino Scardigli. *Prospero, un De Nobili protagonista e cittadino del mondo. In I De Nobili dei Signori di Vezzano*. Sarzana: GD edizioni, 2017, 42-77.

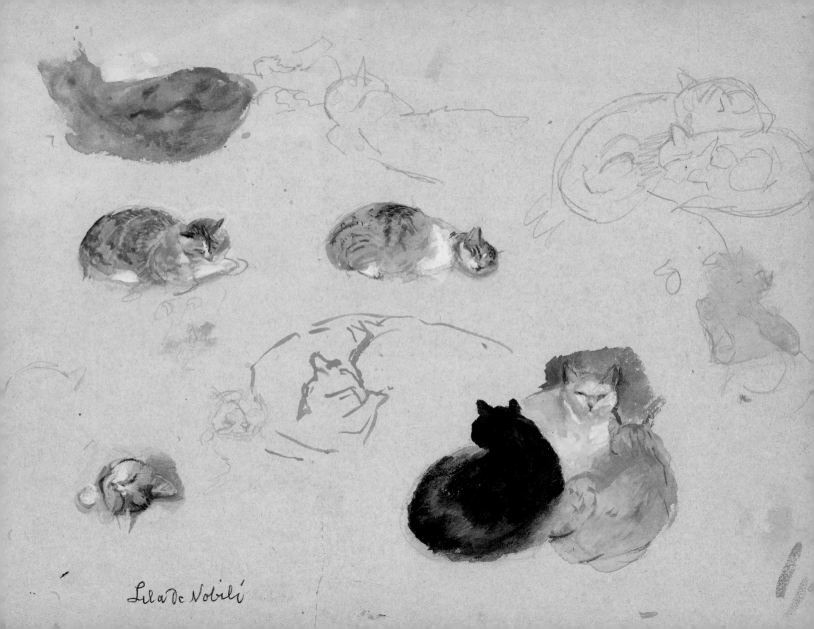

Lila de Nobili